Contents

Front cover:
Pablo Picasso **Grand Profil** 1963 (detail)
Catalogue No. 109

Back cover:
Roy Lichtenstein **Big Painting No. 6** 1965 (detail)
Catalogue No. 74

Picasso to Lichtenstein

Werner Schmalenbach

Picasso to Lichtenstein

Masterpieces of twentieth-century art
from the Nordrhein-Westfalen collection
in Düsseldorf

The Tate Gallery

Translation by Sarah Twohig

Exclusively distributed in France and Italy by Idea Books
24 rue du 4 Septembre, 75002 Paris and Via Cappuccio 21, 20123 Milan

ISBN 0 900874 83 X
Published by order of the Trustees 1974
for the exhibition of 2 October – 24 November 1974
Copyright © 1974 The Tate Gallery
Designed and published by the Tate Gallery Publications Department,
Millbank, London SW1P 4RG
Blocks by Augustan Engravers Ltd
Printed in Great Britain by The Hillingdon Press Ltd, Uxbridge, Middx

Foreword

It is a very rare event for a gallery to be able to present virtually the total collection of another museum. That this is taking place now is due in the first place to the generosity of the Land and the Museum of Nordrhein-Westfalen but it is possible because of the interesting and unique purchasing policy of the Museum.

In the comparatively short period that it has existed it has collected twentieth-century paintings, fundamentally on the single criterion of quality, while deliberately renouncing any attempt to achieve a 'complete' historical collection or to keep up with the avant-garde. While it is quite small numerically it is great in the intensity of the experience it offers.

The funds for purchase, which were made available principally by the Land but also by West German Broadcasting, were at the outset exceptionally generous; several times those of, for example, the Tate Gallery at the same period. They have only diminished in that the rapidly inflating cost of first-rate works of twentieth-century art have reduced their purchasing power. They still remain higher than those committed to the great majority of such specialised museums.

All this is described in Dr Schmalenbach's introduction to the catalogue; I wish simply to emphasise the lesson. The combination of generous and committed support from the State with a well-defined and focused policy and with the knowledge and skill of the director, Dr Schmalenbach, have brought into being in only thirteen years a museum of international standing and quality.

This has taken place in Düsseldorf, a city rather smaller in size than Manchester, which already has a major municipal museum presenting, in an historical manner, the arts of the past and present and a public exhibiting gallery (Kunsthalle) which concentrates on the contemporary. Düsseldorf is only one of the major cities in the Land of Nordrhein-Westfalen, the Government of which has, of course, an infinity of other commitments.

Such an achievement is both heroic and exemplary. The decision to lend almost the whole collection as a unit and record of the achievement is also a heroic gesture and one that must encourage every one concerned with the art of this century.

We are extremely grateful, therefore, to the Land of Nordrhein-Westfalen and to Dr Schmalenbach and his staff for proposing and providing this exhibition.

Norman Reid, Director

Introduction

The history of this museum is unusual. To start with it is exceptionally short. Founded in 1961, it began buying pictures in the autumn of 1962. The initial impetus came in 1960 when the regional government of Nordrhein-Westfalen, of which Düsseldorf is the capital, bought eighty-eight works by Paul Klee from a private collection in America and put them on permanent exhibition in Schloss Jägerhof an eighteenth-century mansion in the city. To this day the 'Kunstsammlung Nordrhein-Westfalen', to give it its official title, is still provisionally housed in this beautiful but spatially inadequate setting. Plans for the much needed new building in the centre of the city are currently being drawn up.

The museum is also unusual because it came into existence as the result of a political decision. For, in contrast to almost all other museums which have grown and developed gradually over a long period, the Düsseldorf collection was founded specifically by parliamentary decree. It is a creation rather than an organic growth, a 'museum ex nihilo'.

The acquisition of the Klee collection established the pattern of future purchasing policy in two respects. First, from the historical point of view, in that it was decided not to include any artists earlier than Klee's generation. The Impressionists and Fin-de-Siècle artists were excluded and, following what was in any case a clear art-historical break at this time, the collection started with the Fauves, the Cubists and the Expressionists. The precedent of the Klee pictures also established quality as the central concern of the collection. Indeed, quality is the sole criterion. All other factors — historical, national, regional, local — have been disregarded.

We have confined ourselves exclusively to the painting of the twentieth century in order to avoid a senseless dissipation of available funds. That the limits of painting are sometimes exceeded is due to the fact that painters themselves have moved beyond those limits. On the other hand, sculpture, drawings and prints remain, for the time being at least, outside the scope of the collection.

The overriding theme of quality was complemented by the unique opportunity of building up a collection right from the start — apart that is from the Klee Collection and the subsequent special gift of a hundred works by Julius Bissier. As there were no stipulations to take into account, we were able to establish quality as our single criterion for acquisition from the beginning. This is not intended as an historical collection. The individual works of art are not included merely because they are examples of a particular historical process. We are not concerned with the documentation and demonstration of art history; on the

contrary, we have made it our aim to present the individual work of art on its own merits. The historical context, without which even this 'piece by piece' kind of collection is obviously unthinkable, is established of its own accord almost as a side effect; it is never the reason for choosing a picture. Historical information is conveyed by methods outside the collection itself; exhibitions, catalogues, lectures. and in particular a specifically didactic annual exhibition. during which most of the pictures in the collection are relegated to the basement.

At a time when the very existence of museums is under fire, the Düsseldorf collection is holding fast to the concept of a museum. At a time when the concept of quality is under fire, we are holding on to that too. It is our basic conviction that a museum has both primary and secondary functions to fulfil. Its primary functions are the collection, preservation and presentation of works of art; all other functions which are the focus of current debate about the 'living museum' are purely secondary. And although these secondary functions are absolutely vital to a museum, the important thing, however, is that the primary functions and the notion of quality should always remain in the foreground, even given the undeniable problems connected with the latter concept.

The criterion of quality presents especial problems with regard to contemporary art, since proximity in time greatly undermines critical objectivity. In addition to the fact that there is no such thing as an absolutely objective judgement, but at best only a maximal sense of subjective certainty, one is also on less secure ground with contemporary art than with the 'classic moderns'. At the same time one is in every instance inescapably faced with the decision of making a choice. One can be broadly accommodating and acquire as quickly as possible as many works as possible that move into the contemporary field of debate, and thus leave it to history to make the final decision and relegate the greater part to the storehouse. Clearly, this is a somewhat passive approach which runs the risk of being conformist and opportunist. But anyone who credits this kind of approach with courage and a willing acceptance of risks is forgetting that there can be no talk of courage where there is no danger of breaking one's neck. The avant-garde, which now enjoys general acclaim, has a status very different from the one it had in 1925 when it was a solitary oasis in the desert. The museum must draw the relevant conclusions from this.

For the Düsseldorf Museum this means in effect that it is prepared to forego the honour of being an avant-garde museum, though this in itself is a contradiction. The concept of an avant-garde is above all an historical and not a

qualitative criterion, and thus conflicts with the basic tenets of this collection. The avant-garde aspect is relevant only with regard to the gallery's secondary functions, particularly in the field of exhibitions. It has no bearing whatever on the collection itself.

Since 1962 the collection has grown slowly but steadily according to these principles. This has been largely due to the funds placed at the museum's disposal each year by the Land of Nordrhein-Westfalen and to two special donations from Westdeutsches Fernsehen. In 1965 the collection was opened to the public for the first time in Schloss Jägerhof in Düsseldorf. The subsequent growth of the collection has meant that only a part of it can be shown there at any one time; many valuable works have to remain in store. In 1968 the entire collection was shown at the Düsseldorf Kunsthalle and in 1970 an exhibition was held at the Zurich Kunsthaus; the current show at the Tate Gallery is a further mile-stone.

I should like to express my thanks to the Tate Gallery, in particular to its Director, Sir Norman Reid, for making it possible for these pictures from Düsseldorf to be exhibited there over the coming weeks.

Werner Schmalenbach

André Derain 1880-1954

30
Bateaux à Collioure 1905
Boats at Collioure

Entry on p.82

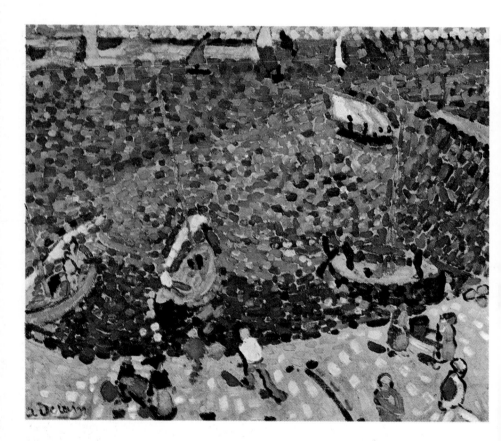

Max Ernst b.1891

35
Après Nous la Maternité 1927
After us Maternity

Entry on p.92

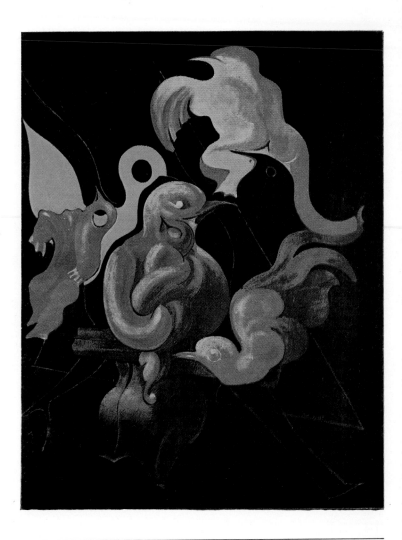

51
Composition 4 1911

Entry on p.124

54

Mädchen unter Japanschirm *c.*1909
Girl under a Japanese Umbrella

Entry on p.130

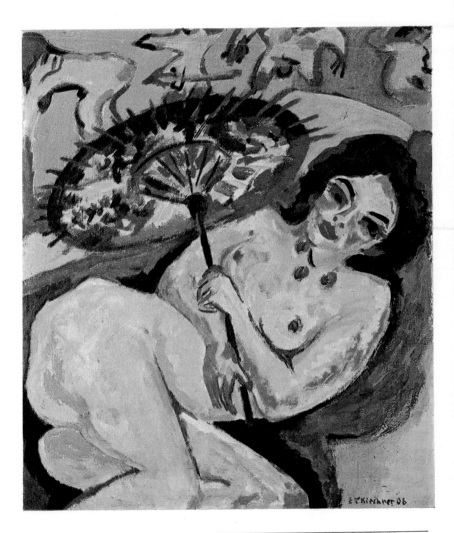

58
Kosmische Composition 1919
Cosmic Composition

Entry on p.138

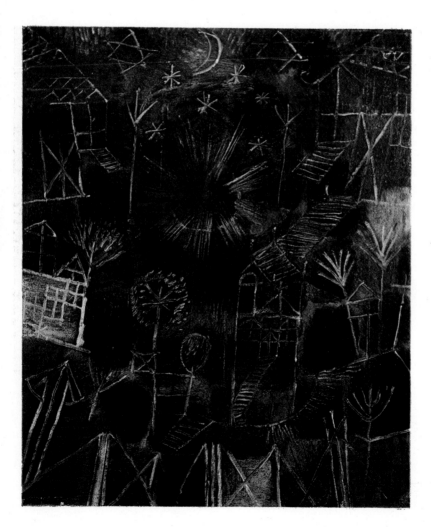

Fernand Léger 1881-1955

73
Adam et Eve 1935-9
Adam and Eve

Entry on p.168

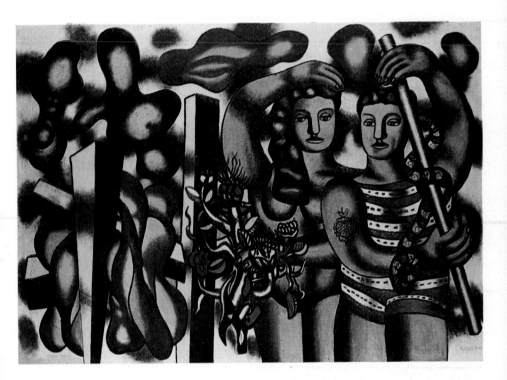

74
Big Painting No. 6 1965

Entry on p.170

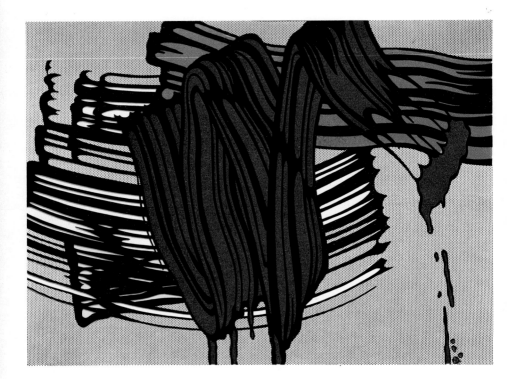

84
Intérieur Rouge, Nature Morte sur Table Bleue 1947
Red Interior, Still Life on a Blue Table

Entry on p.190

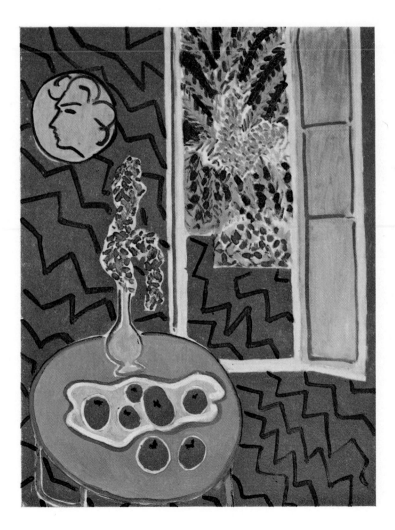

Joan Miro b.1893

87
Personnages Rythmiques 1934
Rhythmic Figures

Entry on p.196

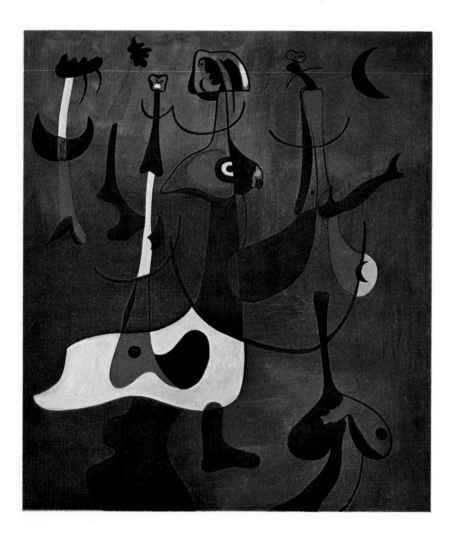

107

Femme Assise dans un Fauteuil, 12 Octobre 1941

Woman in an Armchair

Entry on p.236

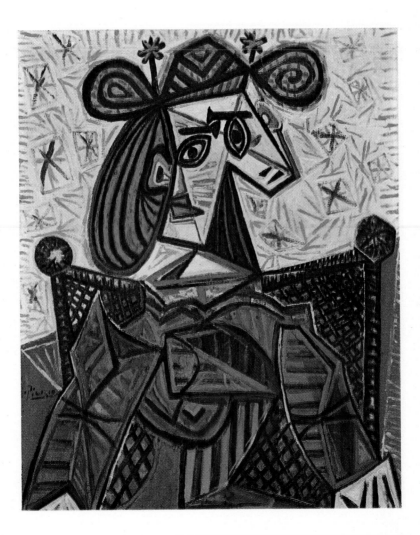

114
Number 118 1961

Entry on p.250

Catalogue

Artists are listed in alphabetical order.
Dimensions are given in centimetres and (in brackets)
inches ; height precedes width.

1

Homage to the Square, Red V a 1967

Oil on hardboard, 121.5 × 121.5 (47$\frac{5}{8}$ × 47$\frac{5}{8}$)
Signed bottom right : A 67
Signed and inscribed on reverse : 'Red' V a Albers 1967

Josef Albers studied and later taught at the Bauhaus. When he went to America he continued to pursue and to teach traditional Bauhaus ideas, and to develop an approach to painting based on the principles of colour theory which excluded both subjective and emotional elements. In his latter years he consolidated these principles within a single theme – the square. Through the constant repetition of one primary formal concept – permitting only variations of size and colour – he made a considerable contribution to the concept of 'serial' painting which became popular in the 1960s. Of specific importance for Albers is the way in which absolute form, symbolized by the square, is linked to the relative quality of the colours, and the fact that a strictly rational artistic exercise can produce results of a spiritual and meditative character in which the rational principle shifts imperceptibly yet unequivocally towards the irrational.

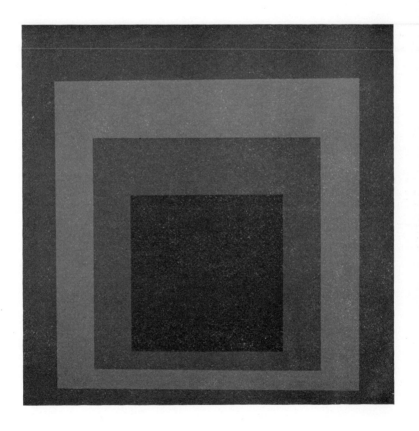

2
Homage to the Square, Suffused 1969

Oil on hardboard, 122 × 122 (48 × 48)
Signed bottom right : A.69
Signed and inscribed on reverse : 'Suffused' Albers 1969

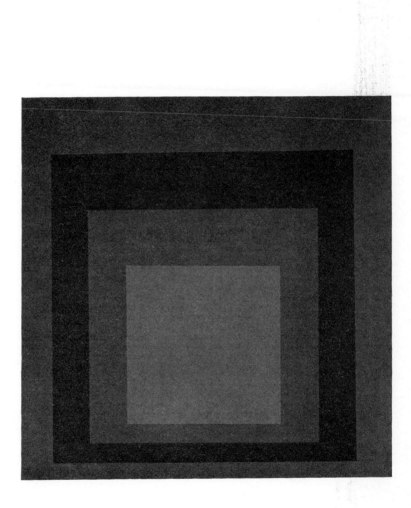

3
Figur Schwarz-weiss 1967
Figure in Black-and-White

Aquatec on canvas, 150 × 120 (59 × 47¼)
Signed and inscribed on reverse : Figur Schwarz-weiss Aquatec Antes 1967

A two-legged, one-armed being with a double-eyed profile, like the ritual fig-
ures in ancient Mexican picture-writing. Antes calls these beings that crop up
throughout his work 'art figures', thus indicating that their existence is a purely
artistic one, not mythological or demonic and certainly not natural. The theme is
neither man, nor demon, nor idol, but simply figure. If gesture and glance do not
immediately reveal their meaning, the artistic methods employed are strikingly
obvious : unbroken colours, a simple geometric organization of the picture
space, and the silhouette-like forms of the landscape and clouds. The expres-
sive handling of his earlier pictures has given way to a styleless anonymity. The
'personal' quality no longer lies in the brush strokes but in the inventiveness of
the composition.

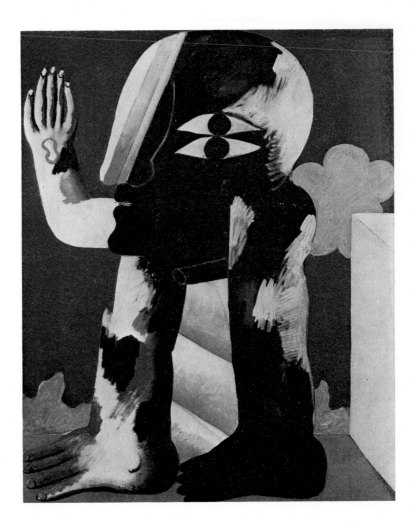

4
Amphora 1931

Painted wood relief, 140 × 110 (55⅛ × 43¼) including frame
On reverse : label added later bearing the following caption : ARP Vase 1930
Despite this information the relief was referred to in a 1933 auction catalogue as
having been executed in 1931.

This relief by Arp dates from after his Dadaist period, which lasted until the mid-1920s. With its swelling vase form and dots 'arranged according to the laws of chance' it belongs to the series of early large-scale reliefs which are his major contribution to what is known as 'concrete art'. Like his friend Piet Mondrian, Arp strove to achieve absolute form. But, unlike Mondrian's geometric art, Arp's biomorphic work sometimes includes references to real objects, such as the amphora suggested here. Though strictly two-dimensional, there is a strong plasticity about the work, understandable in view of the fact that Arp produced his first fully sculptural works that same year.

5

Lying Figure No. 3 1959

Oil on canvas, 198.5 × 142 (78$\frac{1}{8}$ × 56)
Unsigned

Though Francis Bacon was initially stimulated by Surrealism, his work is closer in feeling to the Existentialists than to the pre-war Surrealists. In a uniquely personal way it encapsulates man's isolation and the brutal manner in which he is thrust into the world. This links him with another artist a few years older than himself, namely Giacometti. And yet the contrast between the two could not be greater; for Giacometti spiritualizes man to such an extent that he is virtually devoid of any physical existence, whereas Bacon dramatically emphasizes man's physical aspects. Giacometti depicts man as integrated with the space surrounding him, yet at the same time magically removed from it. With Bacon, on the other hand, man has an undefined, extremely precarious resting place. Giacometti suggests man's alienation by means of his reserve, frontality and lost gaze; Bacon achieves the same effect by means of brutal nakedness, grotesquely distorted limbs and a facial expression which suggests that the figure is seized by the suffocating paroxysm of death.

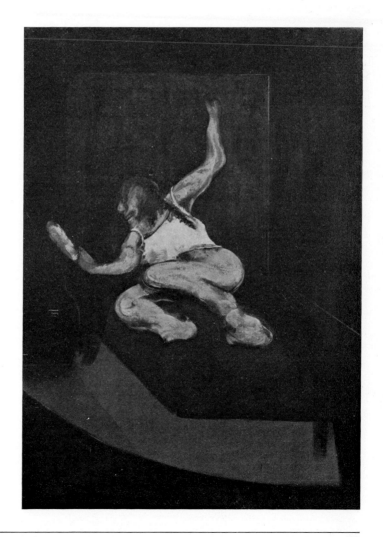

6
Mauerbild mit Metallen 1923
Wall Painting with Metals

Gold leaf, pieces of cardboard and oil on canvas, 89 × 61 (35 × 24)
Signed on reverse : W Baumeister

Geometry, flatness, simplification and the abstraction of the human figure are essential elements in Baumeister's early work. As a result he has tended towards mural painting – like many of the French Purists with whom he has kept in personal contact. The title 'Wall Painting' documents and underlines this aspect of his work.

6

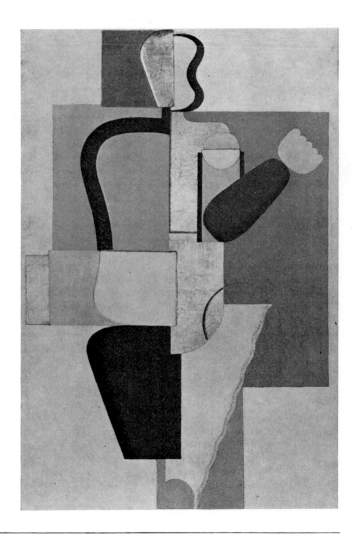

7
Montaru-G VI 1954

Oil on hardboard, 185×130 ($72\frac{7}{8} \times 51\frac{1}{4}$)
Signed and inscribed bottom right : 'Montaru-G' 1954 Baumeister

After the Second World War Baumeister went through a number of different phases of development. From 1953-5 he painted a series of pictures to which he gave the collective name 'Montaru'. They are all characterized by a dominant black area floating in space with numerous marginal forms playing round it. The title 'Montaru' is an invented word ; it relates to the exotic or mythological regions that feature again and again in Baumeister's work, to the unknown continents he 'discovered' through his paintings and to the notion of exploration contained in his book *The Unknown in Art* (Das Unbekannte in der Kunst) published in 1947.

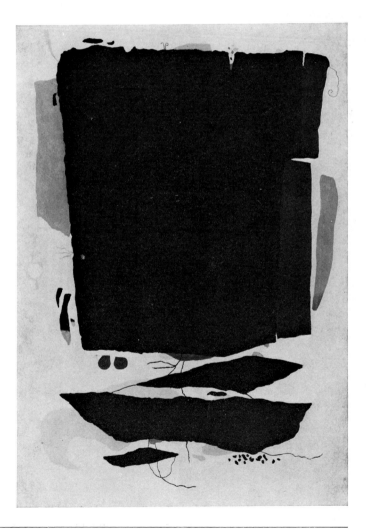

8
Lune et Oiseau de Nuit 1947
The Moon and Bird of the Night

Oil on canvas, 130 × 97 (51¼ × 38¼)
Signed bottom right : BAZAINE 47
Signed and inscribed on reverse : BAZAINE 1947 Lune et oiseau de nuit

Bazaine was the leading member of a group of artists which came to the fore during the German occupation of Paris. In 1941 they held an exhibition entitled : *Jeunes Peintres de Tradition Française*. The artists concerned were all on the way to non-figurative art and saw it as their mission to unite the traditional qualities of French painting with the principles of abstraction. They were thus able to escape the dogma attached to abstract art and to imbue it with new strength. This early work of Bazaine's, despite its geometrical structure with echoes of Cubism and its subdued colours, is a relaxed, richly varied painting. The contours of the bird can just be made out through the maze of lines.

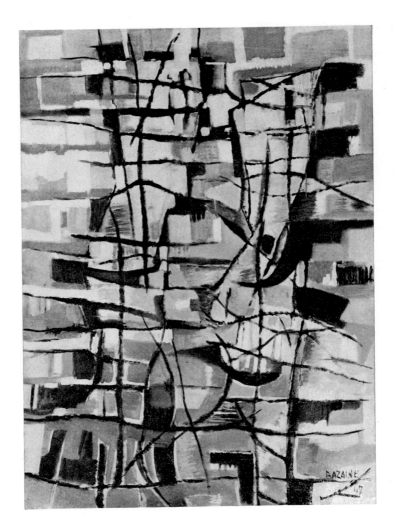

9
Pierre 1955
Stone

Oil on canvas, 120.5 × 60.5 (47½ × 23¾)
Signed bottom right : BAZAINE 55
Signed and inscribed on reverse : BAZAINE 1955 Pierre

Bazaine's continual concern is to transmit nature in terms of paint, hence his increasingly non-figurative art is softened by a pantheistic sensibility. By comparison with the earlier picture, the interweaving of colour, form and nature in this work has become even denser. Rock, water, space and light are all directly evoked by painterly means.

9

10

Die Nacht 1918-19
Night

Oil on canvas, 133×154 (52¾×60⅝)
Signed bottom left: August 18 – März 19 Beckmann

Beckmann painted this major work of his early period in Frankfurt in 1918-19. It reflects his shocked impressions of the First World War, especially the field hospitals in Flanders, as well as the current all-pervading mood of instability and hopelessness. It shows a scene of unbridled horror in which the brutality of the action is reflected in the pictorial means. Cold-blooded murder is being committed in a totally impersonal, matter-of-fact way; the theme itself is as pitiless and merciless as the naturalistic rendering. But this is no conventional naturalism, for it is heightened by outrageous expressions, grimaces and repulsive distortion. It does not derive its inspiration from ancient Greece nor from the sculpture of primitive peoples, but from late medieval German art.

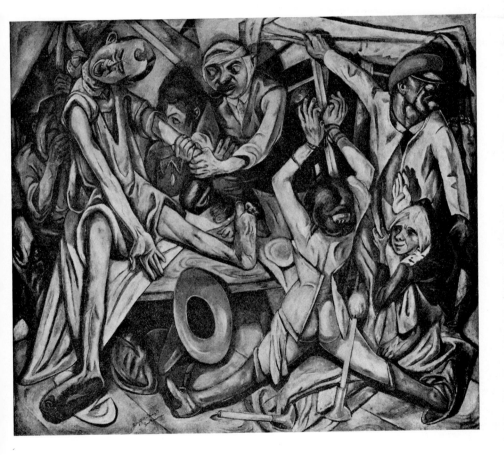

11
The Cabins 1948

Oil on canvas, 140.5 × 190.5 (55$\frac{3}{8}$ × 75)
Signed bottom right : Beckmann 49
Painted in 1948, dated 1949

Beckmann paid his first visit to the United States in 1947. In 1949 he returned to settle in New York, where he died in 1950. 'The Cabins', painted following his return from the first trip in June 1948, is greatly influenced by his impressions of America. Its roughly carpentered composition of scenes in separate compartments lends it the character of a strip cartoon, as well as being reminiscent of the cycles of saints' lives in medieval stained glass windows and of the woodcut elegies used by ballad singers. The title indicates more clearly than the picture itself that the scene is set in the cabin and hatchway of a ship, or perhaps a houseboat like those at Amsterdam where the picture was painted. The centre is dominated by the large diagonal of a fish tied to a plank which is being clasped by a sailor. In the separate compartments there are various figures which we involuntarily associate with the sailor, possibly representing the different stages of his life. The sombre colours complement the enigmatic theme.

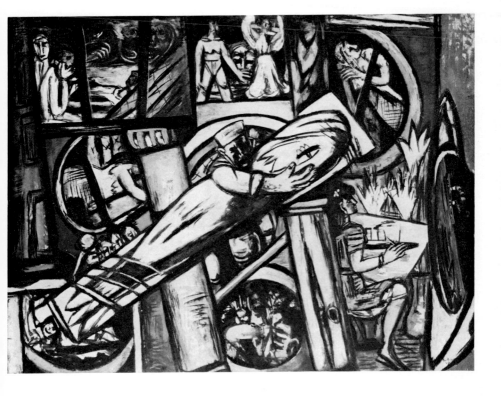

12
22. XI. 56 1956

Tempera on canvas, 15 × 25.4 (5$\frac{7}{8}$ × 10)
Signed bottom left and top right : Julius Bissier [and] 22.XI.56

Until 1923 Bissier pursued a line of development which he increasingly felt to be a dead-end, namely figurative and representational painting. Towards the end of the 1930s the desire for a more directly spiritual approach, which for him was the sole raison d'être of art, led him to restrict himself to the simplest forms and also to the simplest technique — wash drawings in black and white. Between about 1930 and his death in 1965 he painted an unbroken series of abstract wash drawings which form the larger part of his entire work. From the mid-1950s on he devoted his remaining time to a number of small format tempera paintings on canvas which he referred to as 'miniatures', and in which he permitted himself the use of colour. Whereas the water colours bear the direct imprint of the artist's spirituality, in the tempera paintings the world conceived by the intellect is seen as a 'microcosm' of a more objective kind. It is essential to the aim and effect of his pictures that they should always have a spiritual as well as an aesthetic content.

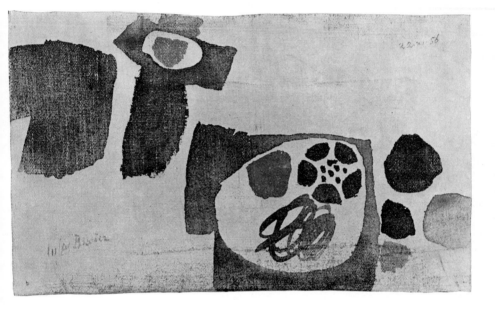

13
A. 30. Sept. 62. 2. Dunkle Ampel 1962
The Unlighted Lamp

Tempera on linen, 17.1×26.6 ($6\frac{3}{4} \times 10\frac{1}{2}$)
Signed and inscribed bottom right: A. 30. Sept. 62. 2. Jules Bissier
Inscribed in centre: dunkle Ampel

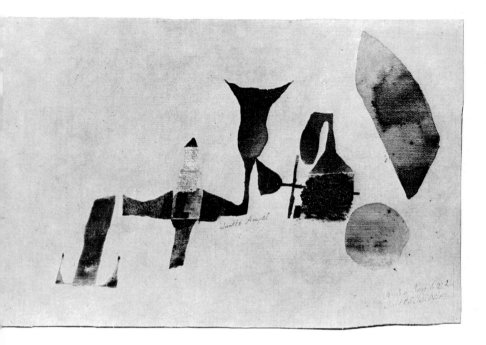

14

22. Mai 61 1961

Tempera on cotton duck, $43.5 \times 48.5 (17\frac{1}{8} \times 19\frac{1}{8})$
Signed and inscribed bottom left: 22 Mai 61 Jules Bissier

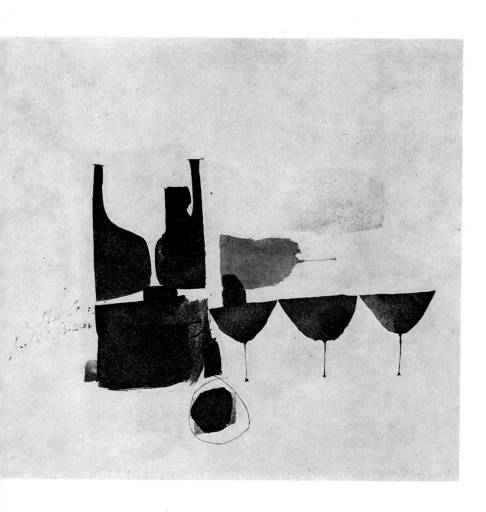

15
14. Juli 61 1961

Tempera and gold leaf on cotton duck, 44×51 (17$\frac{1}{4}$×20$\frac{1}{8}$)
Signed and inscribed middle left: 14. Juli 61 : Jules Bissier

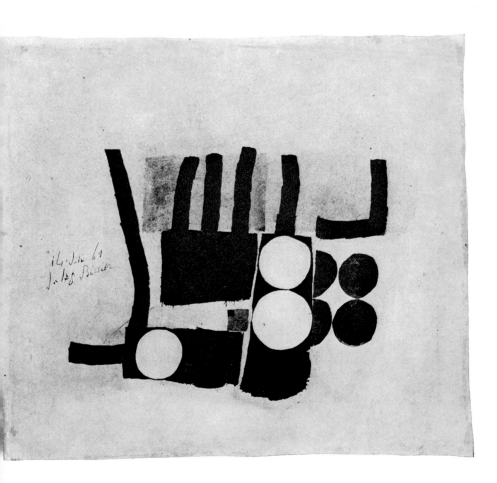

16
A. 12. Febr. 64 1964

Tempera on cotton duck, 40.2×50 (15¾×19⅝)
Signed and inscribed bottom right: A. 12. Febr. 64 Jules Bissier

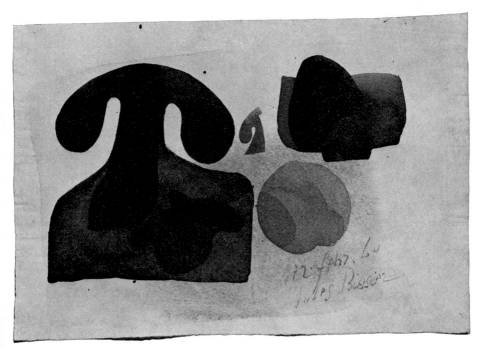

17

Untitled 1959-60

Welded steel and tent canvas, $175 \times 182 \times 61.5$ ($68\frac{5}{8} \times 71\frac{5}{8} \times 24\frac{1}{4}$)
Unsigned

In a large number of her works the American artist Lee Bontecou has stretched pieces of torn canvas over rough, outward curving iron constructions. This framework is strictly functional, but without seeming so. It throws into relief the technical achievements of our time by its craftsman-like improvisatory approach. Yet the resulting forms are reminiscent of the advanced technology of for instance, aeroplane engines. Anti-technology is shown to be formally analogous to a highly technical construction.

17

18
Paysage de La Ciotat 1907
Landscape at La Ciotat

Oil on canvas, 38 × 46 (15 × 18⅛)
Signed bottom left: G Braque

From 1905-7 Braque was affiliated with the Fauves. This small Mediterranean landscape was executed in 1907 according to the Fauvist creed of pure colour, though he strikes a more lyrical and harmonious mood than that concurrently adopted by Derain and Vlaminck. But just a few months later Braque's Fauvist period came to an end. The confrontation with Picasso's 'Demoiselles d'Avignon' in 1907 led him off into a totally different direction, where colour gave way to a colourless, almost monochrome treatment of form.

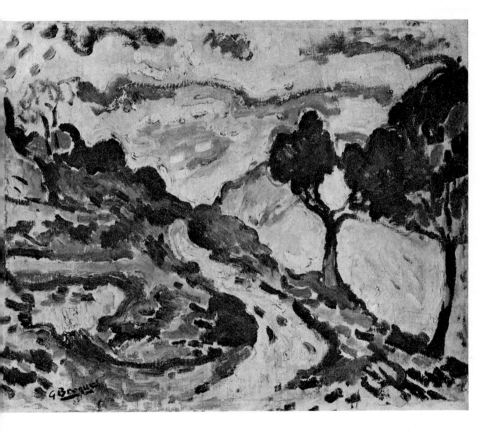

19
Nature Morte, Harpe et Violon 1912
Still Life with Harp and Violin

Oil on canvas, 116 × 81 (45$\frac{5}{8}$ × 31$\frac{7}{8}$)
Signed on reverse : G Braque

Around 1912 Cubism made the transition from its 'analytical' to its 'synthetic' phase. The formal analysis of the object was now replaced by the synthesis of these liberated forms into an autonomous object or picture. In this process the composition and its elements assume a flatness, whereby the term Cubism loses some of its relevance. Braque's 'Nature Morte, Harpe et Violon' stands midway between these two phases. Violin, harp, table and glass are reduced to musical elements in the multiple rhythm of linear forms, just as fragments of words strewn across the surface denote a newspaper lying on the table. Colour is still confined to the typical Cubist monochrome scale of brown, ochre, and grey, though treated with greater freedom than in the analytical period. The picture is characterized by its clarity of composition and precision of form and is pervaded by a sense of luminosity and lucid spirituality.

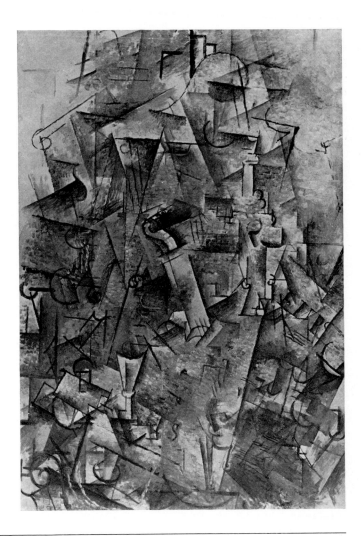

20
Nature Morte au Compotier, Bouteille et Mandoline 1930
Still Life with Fruit Dish, Bottle and Mandolin

Oil on canvas, 116 × 90 (45⅝ × 35½)
Signed bottom left : G Braque 30

This picture indicates the artist's continued loyalty to Cubism as well as the extent to which he had distanced himself from it by 1930. Unlike the still life of 1912 it no longer speaks the language of his 'period of genius', but that of the maturity and absolute mastery of the fifty-year-old, who works freely with the forms liberated two decades previously, and has long since begun to develop a great personal style far removed from any artistic programme. After the initial shock of Cubism the French tradition of painting continued along a changed but unbroken line.

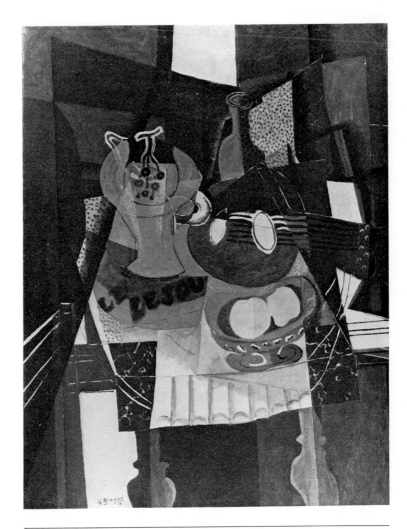

21
L'Atelier II 1949
Studio II

Oil on canvas, 131 × 162.5 (51½ × 64)
Signed bottom left : G Braque
Inscribed on back of frame : L'ATELIER – II –

Even this painting of 1949 contains Cubist references. It is one of a series of eight paintings of his studio – though numbered freely from one to nine – executed by Braque between 1948 and 1955. They form the crowning achievement of his life's work. In them the artist sums up his entire artistic existence. 'L'Atelier II' is a picture of equal pictorial and intellectual fascination, multi-layered in every sense : in composition, handling and intellectually. All the 'dead' things in the studio take on a mysterious kind of life, and among them a large, ghost-like bird appears like a messenger from another sphere.

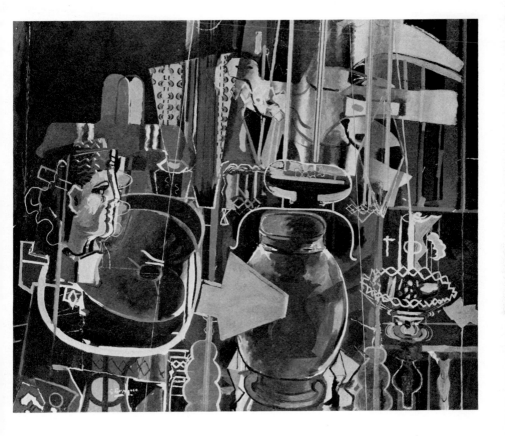

Alberto Burri b.1915

22
WHEAT 1956

Sacking, 150 × 250 (59 × 98½)
Signed on reverse : Burri 56

The Italian artist Alberto Burri composes his pictures out of scraps of old corn sacks, burnt-out wood veneer, sheet iron and sheets of plastic. In his sacking pictures he accepts freely any tears, seams, patches and imprinted letters. He incorporates all these chance effects and complications of the material in clear, well-ordered compositions. Burri is concerned with composition in the tradition-al understanding of the term. But he is also very interested in the shock effect of materials, and hence in something very alive and disquieting which contradicts the idea of transmitting reality to a higher existence through 'art'.

22

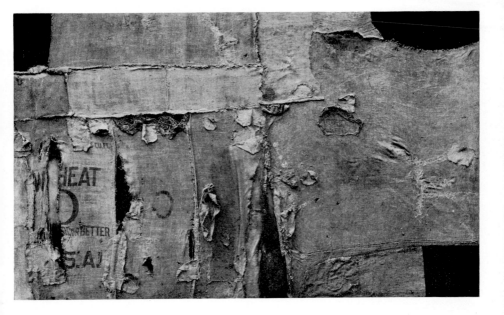

23
La Figlia dell'Ovest 1919
The Girl from the West

Oil on canvas, 90×70 (35½×27½)
Signed bottom right: C. Carra 1919

The Italian 'Pittura Metafisica' movement began in 1916 when de Chirico met Carlo Carrà who was in the process of freeing himself from Futurism. In 1919 Carlo Carrà painted 'La Figlia dell'Ovest', depicting a girl tennis player standing in a dreamlike but meaningless setting — with her racket and ball, but minus a partner. Carrà sees mankind as comprehensible and incomprehensible at one and the same time. The girl is not a thinking, seeing person, but a blind figurine symbolizing the enigma of human life. The stage-like setting consists of an empty house with blind arcades instead of windows, symbolizing the lost paradise of Italian history; two objects without any apparent meaning or purpose; and the magical lines which define both the net and the glassy, unsubstantial wall. In terms of painting technique Carrà has delved back as far as Giotto: the progressive Futurist approach gives way to a new anarchism.

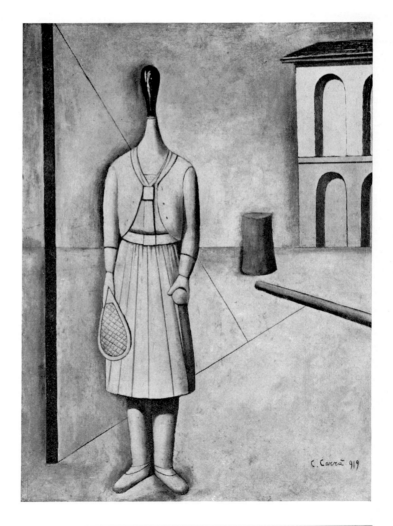

24
Jour de Fête (Le Rabbin au Citron) 1914
Feast-day (Rabbi with a Lemon)

Oil on cardboard, mounted on canvas, 100×81 ($39\frac{3}{8} \times 31\frac{7}{8}$)
Signed bottom right : 1914 Marc Chagall
(and beneath it his signature in Cyrillic letters)

This picture belongs to a series of works which Chagall executed in 1914 based on themes from Jewish rituals. They constitute one of the most impressive groups of his early works. 'Jour de Fête' depicts a man in a prayer cloak holding a lemon in his right hand and a palm leaf in his left — symbols of the Jewish Feast of the Tabernacles. On his head perches a minute replica of himself, as if he were flying out of himself into the strange unknown ; Eastern irrationalism is combined with Latin Cubist rationalism. In Chagall's work Cubism is subservient to figurative representation, and the emphasis lies firmly on the content. But by means of the Cubist interpretation the content becomes incredibly explicit and gains an exceptional degree of pictorial intensity.

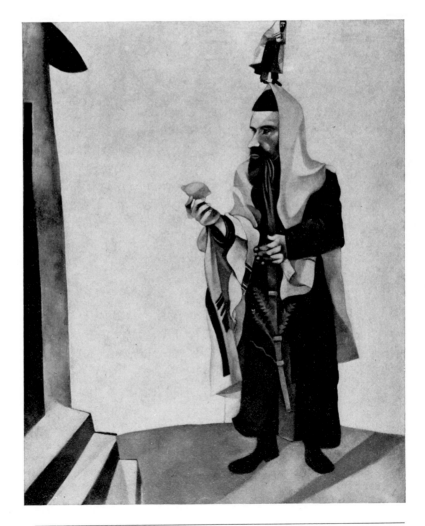

Giorgio de Chirico b.1888

25
La Statue Silencieuse (Ariadne) 1913
The Silent Statue (Ariadne)

Oil on canvas, 99.5 × 125.5 (39¼ × 49¾)
Signed top right: G. de Chirico

De Chirico painted a whole series of pictures in which the focal point is an an-
tique statue – a Roman copy of a 'Sleeping Ariadne' from the Hellenistic period.
He puts the figure in an architectural setting, beside arcades of Quattrocento or
Neo-Classical appearance and a red tower reminiscent of both medieval de-
fences and modern factory chimneys. Antique and modern, myth and present
interpenetrate. By means of such contrasts antiquity appears to be more remote
than ever, and at the same time moves into the dimension of unreality, of the
psyche and of dreams. Thus, in 1913, de Chirico was paving the way for the
transposition of the real into the surreal.

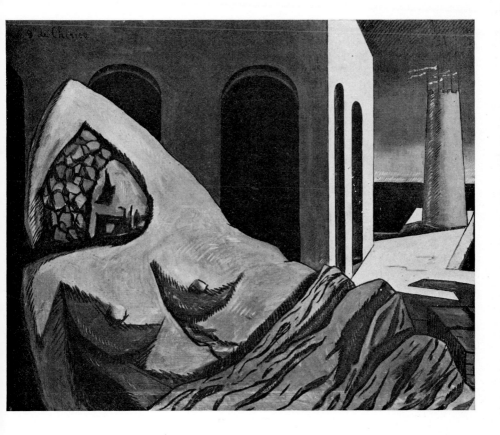

26
Les Deux Soeurs (L'Ange Juif) 1915
The Two Sisters (The Jewish Angel)

Oil on canvas, 55×46 ($21\frac{5}{8} \times 18\frac{1}{8}$)
Signed bottom left: G. de Chirico. 1915

The objects in this picture are depicted with utmost precision yet they have only a faint similarity to things as we know them, and even where they are familiar they occur in unfamiliar surroundings. The two faceless heads remind one of tailor's dummies or shop window models. They have meaning only in the context of dreams. Their life is one of dead figurines. The very tangibility of these objects brought to life intensifies their magical presence. Their strangeness is emphasized by the inherent banality of all the elements in the composition: the dolls, the wooden plank, and even the banal clouds in the banal Italian sky. The two heads belong to de Chirico's personal mythology. They occur frequently in his pictures between 1914 and 1917 in similar and slightly varied arrangements.

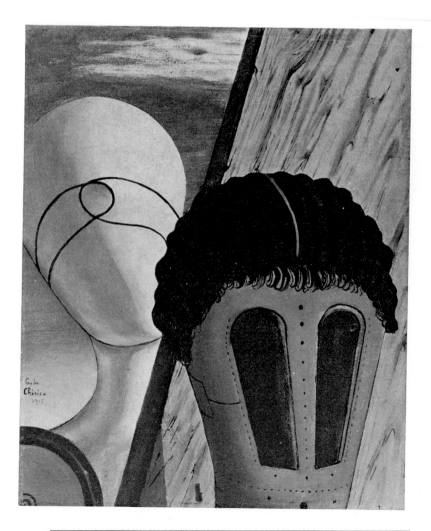

27
Le Cabinet Anthropomorphique 1936
The Anthropomorphic Chest of Drawers

Oil on wood, 25.4×44.2 (10×17¾)
Signed bottom right : Gala Salvador Dali 1936

The motif of the female nude whose body consists of partly opened drawers was inspired by Freud's psychoanalytical interpretation of dreams. Dali himself speaks of the 'narcissistic pleasure' we experience 'on contemplating any one of our drawers'. The motif was also inspired by the 'furnished' human figures of the seventeenth-century Italian Mannerist Bracelli. The panel is painted like an Old Master ; and Dali draws on the florid, skilful draughtsmanship of the German and Italian Renaissance as well as on Dutch interiors with their background glimpses of street scenes.

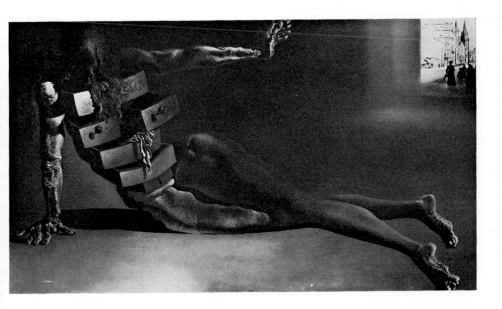

28

La Tour au Rideaux 1910

The Eiffel Tower seen through Curtains

Oil on canvas, 116 × 97 (45⅝ × 38¼)

Signed bottom right : r. delaunay

Another signature and the date [191.] in the centre have been overpainted

The monochrome mood of this painting places it close to classical Cubism, though it refers more explicitly to the object represented — a window framed by curtains opening onto a view of the Eiffel Tower. Unlike the later paintings in which it is reduced to a mere accent of colour, the tower is represented here as a solid iron construction looming up above the houses. Its upward surge follows the upward movement of the eye stage by stage through the picture, and this time-span becomes part of the 'simultaneity' in the picture — an idea that Delaunay took from the Futurists, together with their adulation of technology and large cities.

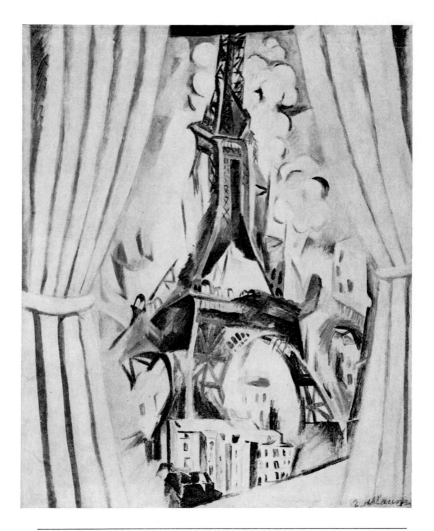

29
Fenêtre *c.*1912-13
Window

Oil on canvas, painted on both sides, 64.5 × 52.5 (25⅜ × 20⅝)
Study for 'L'Equipe de Cardiff', signed DELAUNAY on reverse
Unsigned

The combination of abstract forms and colour freed from all representational associations occurs in exemplary fashion in Delaunay's 'Orphist' paintings, where to Cubist fragmentation of form he adds the knowledge of how light is broken down into its basic colour elements. His 'Fenêtres simultanées' of 1912-13 illustrate this approach. Space and light are suggested solely by means of colour which is distributed in irregular triangles and squares over the surface following the geometric division of the picture space. The sketch-like finish gives the painting its particular floating magic. Delaunay's influence on his contemporaries was extraordinary. It extended to such artists as Léger, Chagall, Klee, Marc and Macke, and beyond them to the first generation of fully abstract painters. Delaunay has proved himself to be one of the decisive reloading points in artistic thought since 1911.

30
Bateaux à Collioure 1905
Boats at Collioure

Oil on canvas, 60×73 (23⅝×28⅜)
Signed bottom left : a derain

Derain spent the summer of 1905 with his somewhat older friend Matisse in the Mediterranean fishing village of Collioure. It was here that he painted this picture of the harbour in such glowing colours that it could almost serve as a manifesto of the Fauvist gospel of pure colour. In some respects it is still openly linked with the tradition of Pointillism, In other ways, however, this tradition has already been superseded. The Pointillist atom of colour has grown to be an indispensable element of the composition, rather like a single stone from the surface of a mosaic.

Reproduced in colour on p.12

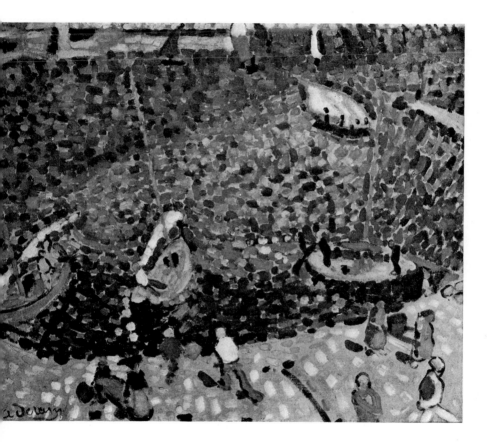

Jean Dubuffet b.1901

31
Les Dimanches Ensoleillés 1947
Sundrenched Sundays

Oil on canvas, 146.5×115.5 (57¾×45½)
Unsigned

In the work of Jean Dubuffet the traditional 'belle matière' of French painting is supplanted by a relief-like surface of coarse materials in which scarcely any individual forms can be discerned: form and structure are one. Dubuffet views 'peinture' as mere decorative art and proposes instead his own idea of 'art brut' in which the material is not only the medium but also the content of the picture. However he also engraves figurative and landscape elements into this matter, as for instance in 'Les Dimanches Ensoleillés' of 1947, a sad, 'petit-bourgeois' suburban scene with houses and fields and paths and a deliberately childishly drawn man in front of the childishly uptilted landscape above which glows a yellow sun.

32
Paysage d'Airain 1952
Brazen Landscape

Mixed media on hardboard, 195 × 129.5 (76$\frac{3}{4}$ × 51)
Signed top centre : J. Dubuffet 52

The 'Paysage d'Airain' of seven years later is entirely covered by pulsating, homogeneous matter. Its structures and textures suggest the idea of earth and stone all the more strongly because of the way the bright, though equally 'materially' structured, sky rises above these 'geological' strata and their undulating horizon.

32

33

La Broyeuse de Chocolat 1914
The Chocolate Grinder

Oil on canvas, 73 × 60 (28¾ × 23⅝)
Signed on reverse : Marcel Duchamp 1914
Inscribed on back of frame : Janvier 1914

The first of Duchamp's 'ready-mades' — banal, everyday objects which he signed, gave titles to and showed in art exhibitions — date from 1913 to 1915. 'La Broyeuse de Chocolat', which can be regarded as a painted ready-made, is closely related to these provocative 'history-making' proto-dada works. It is a simplified, defunctionalized, yet emphatically banal representation of a chocolate grinder such as the artist had seen in a shop window at Rouen. In two other versions of the picture executed in 1913 and 1914, now in the Philadelphia Museum, the machine stands on a round table with rococo legs. The Düsseldorf version shows the grinder without the table. The motif of the chocolate grinder appears in the bottom half of his 'Large Glass' picture of 1915-23 to which Duchamp gave the enigmatic title : 'The Bride Stripped Bare by her Bachelors, even'.

34

La Femme Chancelante 1923
The Equivocal Woman

Oil on canvas, 130.5 × 97.5 (51$\frac{3}{8}$ × 38$\frac{3}{8}$)
Signed bottom right : max ernst [and] 1923

In 1922 Max Ernst moved from Cologne to Paris where he soon became one of
the founder members of the Surrealist movement. In 1923, one year before the
publication of André Breton's first *Surrealist Manifesto*, Ernst painted 'La
Femme Chancelante'. Passive, doll-like — her body half wood, half flesh — the
scantily dressed woman hovers with arms outstretched between the deathly
clamps and stakes of the imaginary torture machine. Above, the machine's
pipes and tubes come to life in a snakelike way, giving the whole configuration
the appearance of an updated 'Laocoon'. For all its menace the machine does
not seem to want to hurt the human figure which resists the murderous on-
slaught in a sleepy, dreamlike trance. The typical elements of Surrealist ideol-
ogy — the fantastic, dreams, somnambulism and sadism — are united in this
picture.

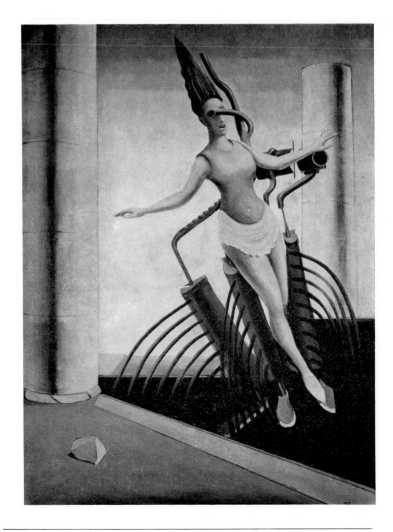

Max Ernst b.1891

35
Après nous la Maternité 1927
After us Maternity

Oil on canvas, 146.5 × 114.5 (57¾ × 47⅛)
Signed on right : max ernst
Signed and inscribed on reverse: max ernst après nous la maternité

This large painting depicts a family of farcical birdlike creatures. It centres round a mother and child group which humorously parodies the most venerated motif of Western art – Raphael's Madonnas. Ernst was constantly preoccupied with the bird image throughout his life, with a particular emphasis on the theme in the mid- and late twenties. For him birds are a kind of personal totem animal ; they appear in his paintings like an 'alter ego', sometimes with fantastic names like Loplop and Hornebom.

Reproduced in colour on p. 13

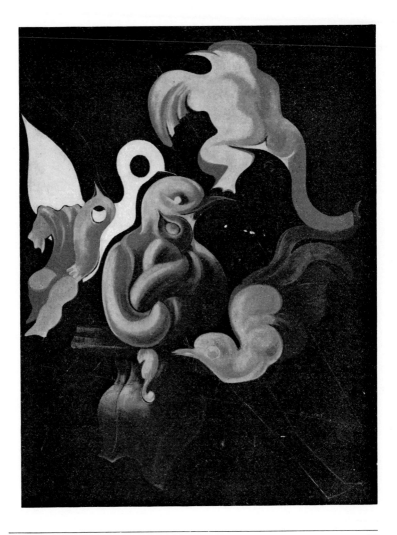

36

Paysage au Germe de Blé 1936
Landscape with Sprouting Corn

Oil on canvas, 130.5 × 162.5 (51¾ × 64)
Signed bottom right : max ernst 1936
Signed and inscribed on reverse : max ernst 36 paysage au germe de blé

During the thirties Ernst's work began increasingly to acquire the character of a rich mythology of natural forms with echoes of Grünewald, Altdorfer and the German Romantics. The 'Paysage au Germe de Blé' is a picture about the growth and function of nature, its luxuriance, its voluptuous fertility. It stands in direct contrast to the series of ultra-naturalistic yet fantastic landscapes executed during the same period.

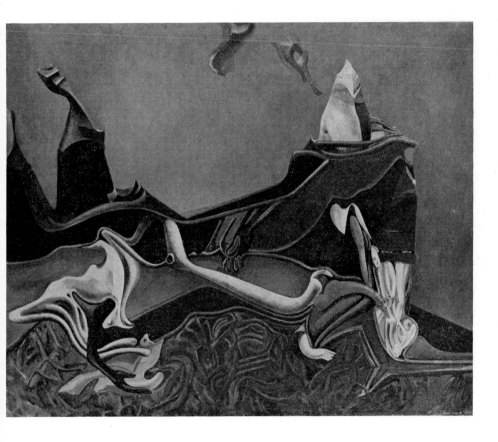

37
The Cocktail Drinker 1945

Oil on canvas, 116 × 72.5 (45⅝ × 28½)
Signed bottom right : max ernst 1945

Ernst took the conventional portrait form as the basis for this picture. It contains references to Guiseppe Arcimboldo (1527-93), the Italian Mannerist painter rediscovered by the Surrealists, and also, in the pyramidal composition and the motif of the arm resting on the lower edge of the picture, echoes of the 'Mona Lisa'. These classical allusions serve to heighten the absurdity. The figure is made up of a conglomeration of natural, man-made and rhombic forms; of plant, object and human elements; of decaying, blooming and dead matter.

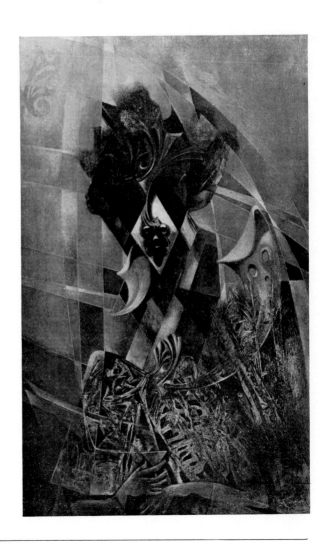

38
Umpferstedt I 1914

Oil on canvas, 131.5×101 (51¾×39¾)
Signed bottom right : Feininger 1914
Inscribed on back of frame : 'Umpferstedt'

Although Cubism did not develop as a movement in Germany, its influence there was widespread, mainly via Delaunay and the Futurists. It is most evident of all in the work of Lyonel Feininger after 1912. In its treatment of objects his large painting 'Umpferstedt I' of 1914 is a Cubist painting : a crystalline formal structure is imposed upon them. However the object is not only subjugated as an autonomous form, but also for intellectual and spiritual reasons. The brown tones of Cubism are replaced by a transparent blue. The pointed form of the village church tower combines with this romantic colour to symbolize that specifically Gothic emotion which is associated with the Expressionist outlook, but is totally alien to classical Cubism.

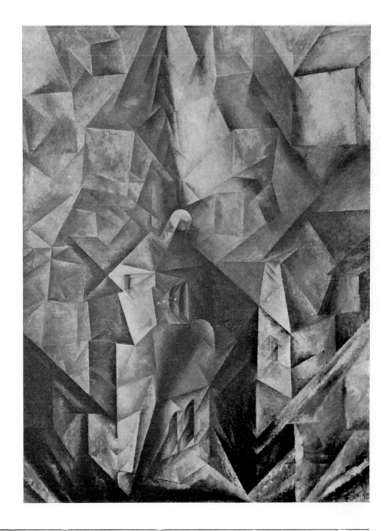

Sam Francis b.1923

39
St-Honoré 1952

Oil on canvas, 201 × 134.5 (79⅛ × 53)
Signed on reverse : Sam Francis 1952

Sam Francis' painting has its roots in American Action Painting, but distances itself from the latter through its pictorial content. Since 1950 Francis has lived on and off in Paris and has therefore been influenced by the climate of European art. Since his first visit to Japan in 1957 his work has also been greatly affected by the Far East. This white painting is dominated by a meditative stillness which seems to indicate that the artist was in some measure already prepared for his encounter with the Orient.

40
Composition Noir et Jaune 1954
Composition in Black and Yellow

Oil on canvas, 194.5 × 130 (76$\frac{5}{8}$ × 51$\frac{1}{4}$)
Signed on reverse : Sam Francis

A soundless cascade of dark forms, a thick shell of cellular tissue spreading in-exorably' over the coloured ground. The process is of a purely painterly nature and permits no specific interpretation. But the intellectual sincerity with which it is executed invests the painting with an evident if enigmatic meaning.

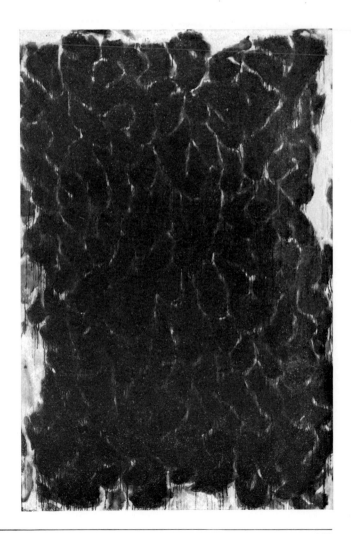

41
Annette Assise 1957
Annette Seated

Oil on canvas, 99.5 × 60.5 (39$\frac{1}{4}$ × 23$\frac{7}{8}$)
Signed bottom right : Alberto Giacometti 1957

The sculptor Alberto Giacometti belonged to the Paris Surrealist group from 1930 until his expulsion from it in 1935. In the late 1930s he began modelling heads from life, thereby disassociating himself artistically from Surrealism. During the war he began the series of thin, elongated figures which continued until his death in 1966. Giacometti painted regularly almost all his life, but it was only after 1945 that he became generally acknowledged as a painter. From that time on he divided his time equally between painting and sculpture. In the last twenty years of his life he executed a large number of portraits, landscapes, still lifes, and studio compositions in which the themes and methods of treatment are as strictly limited as those of his sculpture. One of his most frequent subjects is the figure of his wife Annette posing in the studio. What strikes one immediately is the way her physical presence is almost entirely suppressed by a sense of her spiritual existence.

42
Der Sessel 1965
The Armchair

Oil on canvas, 170×140 (67×55⅛)
Signed bottom right: Bruno Goller

In many respects the sixties saw the introduction of a new objectivity and a new trend towards figurative art. One painter to gain prominence as a result of this development was Bruno Goller, who began his artistic career as a member of the Verist group in the twenties. At this time he could be seen in the context of the Rhineland avant-garde, though he later evolved his own somewhat idiosyncratic style unattached to any movement. However the mood of the times coincided with his work only relatively late in his career. Goller has developed an iconography of banal but symbolically depicted objects: hats, umbrellas, cups, clocks, chairs, mirrors, numbers, oversize ears, also cats, human figures and strange ornaments.

42

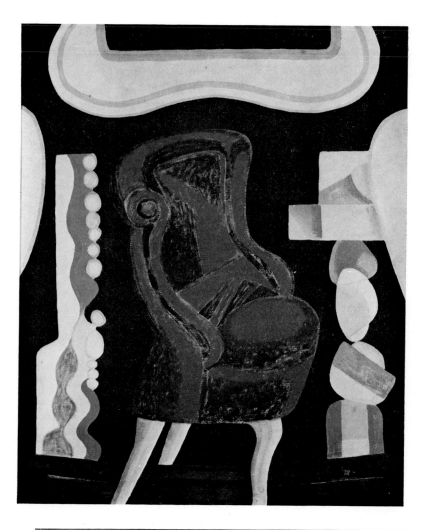

43

Farbraumkörper I 1973
Colour-space-body

Oil on Perlon over synthetic fleece on canvas, 201×131 ($79\frac{1}{8} \times 51\frac{1}{4}$)
Inscribed on reverse : Graubner 73

Graubner's main concern is with the self-representation of colour. By means of a colour-cushion covered with painted Perlon, he gives auto-effective colour actual bodily form: a solid substance which is combined with the immaterial qualities of pure colour and light. Graubner is close to the Düsseldorf Zero Group, but his art belongs to a wider area delimited by names such as Mark Rothko on the one hand and Yves Klein on the other.

44

Farbraumkörper I 1974
Colour Space Body I

Oil on perlon over synthetic fleece on canvas, 181×121 ($71\frac{1}{4} \times 47\frac{5}{8}$)
Signed and inscribed on reverse : Graubner 74 'farbraumkörper' I

44

45
Nature Morte (Le Violon) 1913
Still Life (The Violin)

Oil on canvas, 89.5 × 60.5 (35¼ × 23⅞)
Signed on reverse : Gris 4 – 13

The painting is composed according to the principles of collage. Its vertical sections are placed side by side in strips, as if they had been cut out, shifted slightly, and then remounted. In this way reality is subordinated all the more emphatically to pictorial structure. The semi-circle which closes off the picture at the top is strikingly unconventional and surprising in this context, precisely because it is an essentially conventional motif.

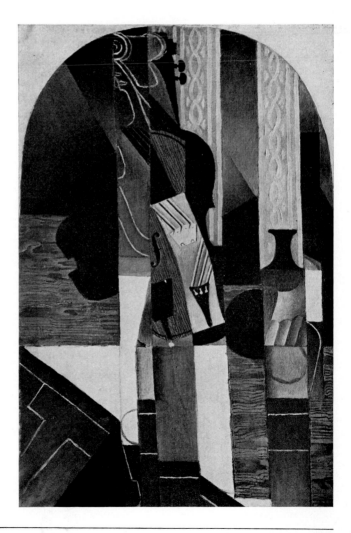

46

Les Tasses de Thé 1914

Teacups

Collage, oil and charcoal on canvas, 65×92 ($25\frac{5}{8} \times 36\frac{1}{4}$)
Signed on reverse : Juan Gris

This large collage of 1914 is undoubtedly one of Gris' most important works. Compared with the improvisation of the somewhat earlier collages by Picasso and Braque, it is a work of unusual harshness and severity. A three-dimensional chess-board pattern has been pencilled in over the top of the table, creating a fascinating if puzzling ambiguity between the surface and the suggested space. Pieces of newspaper and wallpaper form the objects of the still life, which as a result becomes a kind of riddle. The texture of wood is suggested by a piece of wallpaper which in turn denies its own authenticity in that it imitates wood.

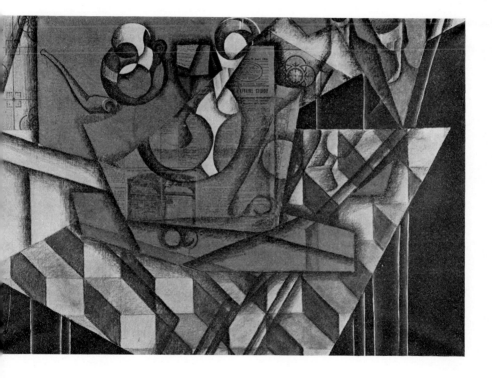

47
Nature Morte au Journal 1916
Still Life with a Newspaper

Oil on wood, 80.5 × 45 (31¾ × 17¾)
Unfinished study on reverse
Signed bottom left : Juan Gris 6-16

This still life of 1916 manifests a stricter, more 'purist' mood than the other two works by Gris shown here. In keeping with his style that year, the colours lie flat and cold on the plywood board. The forms are no longer confined to simple horizontals and verticals, but are piled diagonally on top of one another ; and the pictorial balance has become unstable. The individual objects are absorbed into the overall formal structure in keeping with Gris' declaration that 'an object painted by me is nothing but a modification of pre-existing pictorial relationships'.

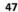
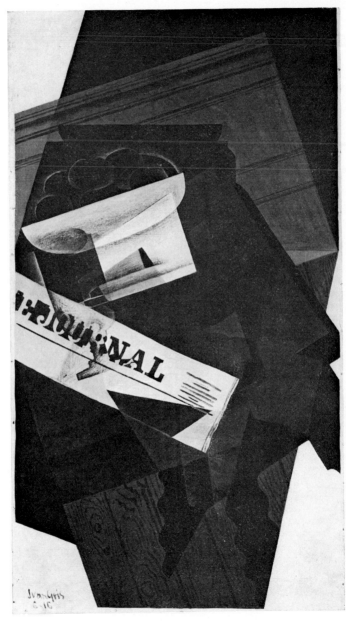

48
Ohne Titel 1920
Untitled

Oil on canvas, 81 × 61 (31⅞ × 24)
Signed on reverse : Grosz 1920
Signed and inscribed on reverse with the artist's stamp and the words : GEORGE
GROSZ 1920 CONSTRUIERT

The 'magic realism' of Italian Pittura Metafisica also had its effect on artists in other countries. Even an artist like George Grosz painted a number of works in 1920 which reveal an intimate knowledge of the pictorial problems of the Italians. This untitled picture is one of that group. Here again we have a faceless, doll-like figure in an empty space devoid of all atmosphere, tangible and material, yet somehow artificial, an urban setting dotted with meaningless objects. But in this case the figure does not appear in the guise of a poetic being as in Carrà's painting, but as a social phenomenon, a symbol of bourgeois man. There is social comment in the rows of dead windows in the righthand corner, in the 'petit bourgeois' green shutters, and even in the structure of the industrial canvas itself. And in contrast to the dreamy, sublime 'Italianità' of Carrà's picture, Grosz shows Berlin of the 1920s not in terms of a poem linking today and yesterday, but as the challenging reality of the present.

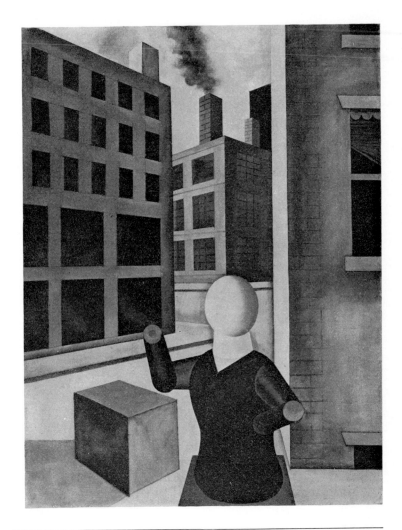

49
T. 38-2 1938

Oil on canvas, 100×149 (39⅜×58⅝)
Signed bottom left: HARTUNG 38
Signed and inscribed on reverse: HARTUNG: T.38-2

Since the war a new concept of non-figurative art has developed in direct op-position to the aims of the geometric artists. This new approach consists of pure graphic gesture in which form no longer appears as form *per se*, but as action. Hans Hartung was one of the pioneers of this kind of art. Born in Leipzig in 1904, he has lived in Paris for the past thirty years. His path of development leads back to early Kandinsky and German Expressionism. But pictures such as this one indicate that Hartung was also influenced by the Surrealist doctrine of 'psychic automatism', by Joan Miró's paintings of the mid-1920s, and by the works of the Spanish sculptor Julio Gonzalez whom Hartung knew personally. The way the swiftly drawn figure is placed on a spatially indicated base points to an iron sculpture which Hartung made under Gonzalez's influence the same year as this picture.

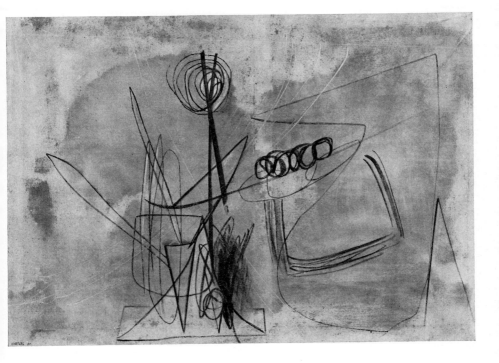

50
T. 49-9 1949

Oil on canvas, 89 × 162 (35 × 63¾)
Signed and inscribed on reverse : T 1949 – 9 Hans Hartung

By 1949 the character of Hartung's work has changed considerably. He is no longer interested to the same extent in unburdening himself subjectively. He is now more concerned with an objective approach to the picture and to its painterly beauty. The expressionist element has retreated and the spontaneity flows into an overall pictorial rhythm. Graphic Expressionism has been replaced by a vocabulary of painterly signs.

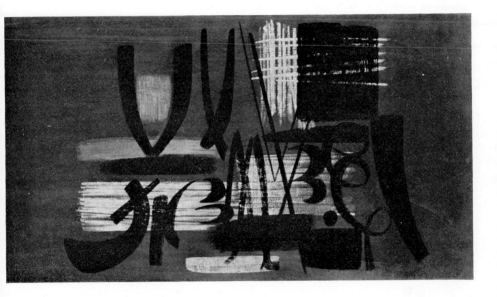

51

Composition 4 1911

Oil on canvas, 159.5 × 250.5 (62½ × 98½)
Signed bottom left : KANDINSKY 1911.
Signed and inscribed on reverse : K –Komposition 4. –No. 125. 1911.

This major work of Kandinsky's early period stands on the threshold of abstract art and must therefore be considered as one of the key works of twentieth-century painting. There are still references to the visible world : a mountain landscape, an abbreviated hill-fort, the shorthand indication of a battle between horsemen above a valley spanned by a boldly coloured rainbow, a phalanx of black lances and three lance-bearers with red caps. However, this is really just a foundation for the magnificent colour and the free, expressive gestural network of black lines. The painting was done in the spring of 1911 and is one of the ten 'compositions' – as opposed to the 'impressions' and 'improvisations' – which Kandinsky painted between 1910 and 1939. The left half of the picture forms the motif of a smaller work in the Tate Gallery.

Reproduced in colour on p. 14

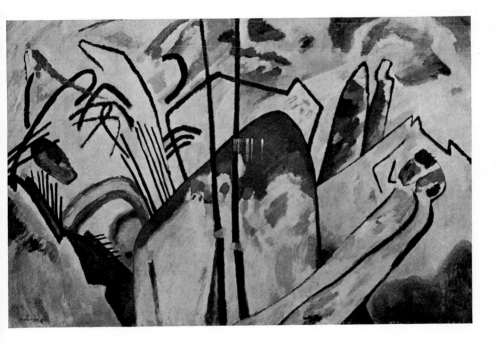

52

Durchgehender Strich 1923
Transverse Line

Oil on canvas, 141 × 202 (55½ × 79½)
Signed bottom left : K 23
Signed and inscribed on reverse : K 1923. 'Durchgehender Strich'. No. 255.

In 1922 Kandinsky joined the staff of the Bauhaus in Weimar, and moved with the school to Dessau in 1925. 1922 marks the beginning of his geometrical approach. 'Durchgehender Strich', a major work of this period, still contains much of the emphatic mood of the previous years, but the vitality of improvisation is now controlled by precision of form. Nevertheless, geometry does not wholly determine the spirit of the picture, for the geometric shapes are simply vehicles for expression : expressive needs are filled by non-expressive means. Form is not, as in Mondrian's work, directed towards an all-embracing objectivity. Its reference remains subjective, to the person actively involved in painting it.

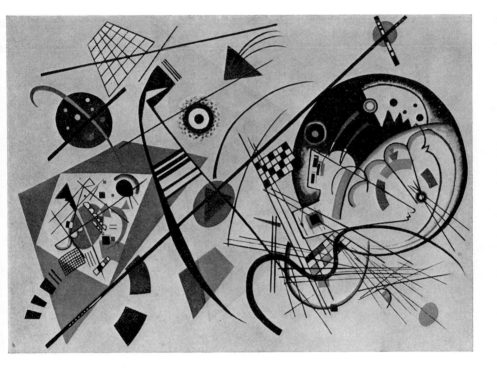

53
Im Blau 1925
In the Blue

Oil on cardboard, 80×110 (31½×43¼)
Signed bottom left : K 25
Signed and inscribed on reverse : K No. 288./1925 'Im Blau'

The stylistic means used in this painting of two years later are also strictly geo-
metric, but here too Kandinsky allows himself a free mobility of form. There is
even a hint of folklore and children's toys. The geometry is scored with a euphoric
brilliance of colour, a brilliance which is at once unified and transformed by the
blue of the ground into the realms of music and the irrationality of dreams.

54

Mädchen unter Japanschirm *c.*1909
Girl under a Japanese Umbrella

Oil on canvas, 92.5 × 80.5 (36$\frac{3}{8}$ × 31$\frac{3}{4}$)
Signed bottom right : E. L. Kirchner 06
Signed and inscribed on reverse : E. L. Kirchner Mädchen unter Japanschirm 06
[This earlier date added subsequently by the artist]

Kirchner's 'Mädchen unter Japanschirm' documents the initial reaction of the German Expressionists to the French Fauve movement. It is dated 1906 but was probably painted in 1909 — at any rate during the early period of the Brücke association of artists in Dresden. It depicts a reclining nude girl whose body is built up of a patchwork of pure colours which set each other ablaze with an intensity which finally explodes like a brilliant firework of colour in the Japanese umbrella. It is very much in the spirit of André Derain, who in his Fauve period, described the painter's tubes of colour as sticks of dynamite.

Reproduced in colour on p. 15

55
Negertanz c.1911
Negro Dance

Distemper on canvas, 151.5 × 120 (59⅝ × 47¼)
Signed bottom left : E. L. Kirchner

Kirchner painted this large scale variety scene in about 1911 while he was still in Dresden, or possibly shortly after his move to Berlin. It belongs to the series of large variety and circus pictures which form as important a part of his oeuvre as the famous street scene series. In contrast to the earlier painting, the colour scheme here no longer includes the luxurious bright colours of the Fauves. Instead, the colours are darker and more tonal and their character owes more to the impatient, hectic brush strokes than to the inherent qualities of the colours themselves. Nevertheless for all his expressive haste Kirchner's aim is to create a major work, a 'grosse Komposition'.

56
Grüne Dame in Gartencafé 1912
Green Lady in a Garden Café

Oil on canvas, 89.5 × 66.5 (35¼ × 26¼)
Signed bottom left in pencil: E. L. Kirchner; and slightly to the right in oil:
ELKirchner

This picture – presumably a portrait of his wife Erna – comes alive both through
the contrast between the rapid brushstrokes, characteristic of Kirchner's Berlin
period, and the stillness of the woman sunk in thought, isolated from the people
around her, and also through the colour which though harsh, does not lack
subtlety.

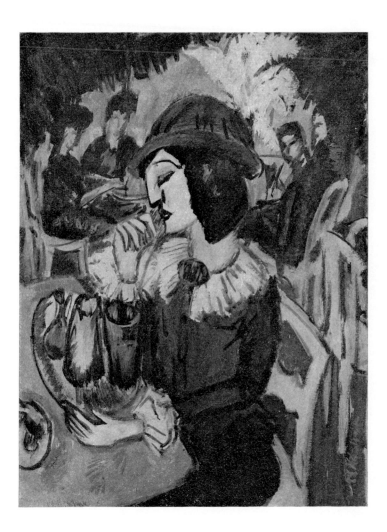

Konrad Klapheck b.1935

57
Der Krieg 1965
War

Oil on canvas, 145×200 ($57\frac{1}{8} \times 78\frac{3}{4}$)
Signed on reverse : Klapheck 65

The generation of Klapheck and Antes has seen the swing away from the domin-
ance of abstraction, and in particular the frenzy of Abstract Expressionism and
the structurelessness of 'art informel'. Even when still a student at the Düsseldorf
Academy Klapheck was fascinated by trivial mechanical objects and he soon
came into contact with Surrealism. In his paintings things assume a magical
character, due not only to his photographic precision, but also to his use of
abstraction and the way he organizes his compositions. Objects are trans-
formed into monsters — as he himself has sometimes expressed it. The five
simplified drills in this work are good examples. Drawn up before a blood-red
sky they bring to mind associations with army generals or industrial overlords, a
'ruling class' or, as the title suggests, war.

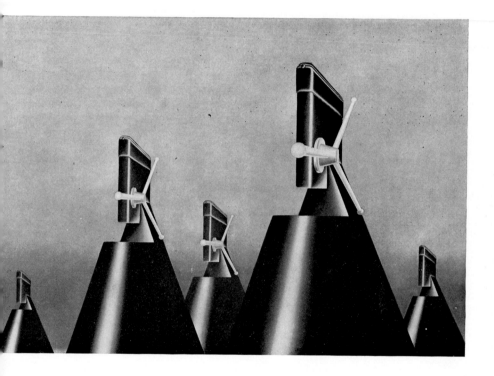

58
Kosmische Composition 1919
Cosmic Composition

Oil on panel, 48×41 (18⅞×16⅛)
Signed on left : Klee 1919. 165.
Signed and inscribed on label on back : 1919 165 Kosmische Composition Klee

It was only after his return from war service in 1919 that Klee was able to take up where he had left off with the water colours executed during and after his visit to Tunis in 1914, and to devote himself to oil painting. Here, within a colourful 'carpet' of abstract forms he has sketched various objects such as a house, stairs, plants and stars, creating a cosmic composition embracing sun and moon, day and night.

Reproduced in colour on p. 16

59
Federpflanze 1919
The Feather Plant

Oil and leather on canvas, mounted on cardboard surrounded by collaged strips
of painted paper, 41.5 × 31.5 (16⅜ × 12⅜)
Signed bottom right: Klee 1919. 180
Signed and inscribed on label on back: 1919.180. Federpflanze Klee

Delicate lines branch from either side of a central vertical, suggesting the shape
of a plant or a feather. Flower-like dots emphasize the essentially object charac-
ter of the colourful forms in this abstract configuration. The ambivalence of plant
and feather is maintained in the compound title.

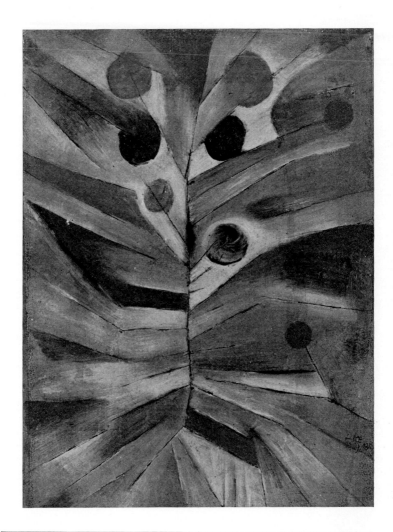

60

Kopf mit deutscher Barttracht 1920

Head with German Moustache

Oil and feather on thin paper, glued to wood, 32.5 × 28.5 ($12\frac{3}{4} \times 11\frac{1}{4}$)
Signed bottom right : Klee. 1920. 22.
Signed and inscribed on reverse : 1920./22. Kopf mit deutscher Barttracht Klee

The title contains an ironic allusion to Kaiser Wilhelm II, whom Klee also ridicules in a drawing of 1920 and a water-colour of 1921. But the mockery implied by the twirled moustache, the hideous mouth and the helmet-shaped forms on the head is outweighed by the graphic and pictorial structure of the work.

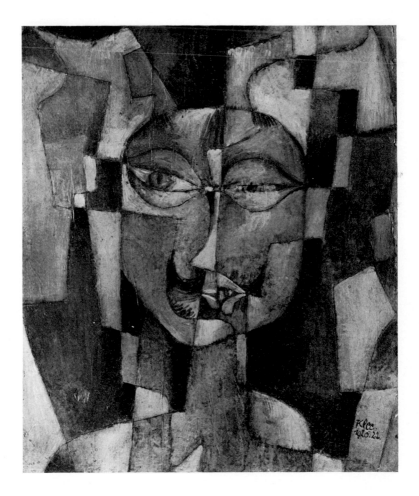

61
'43' 1928

Water-colour on plaster over gauze mounted on a wooden frame
36 × 32.5 (14$\frac{1}{8}$ × 12$\frac{3}{4}$)
Unsigned

This water-colour painted on plaster is one of Klee's few completely abstract paintings, though even here the red 'stars' above the green conjure up associations with landscape. Typographic numbers and letters occur frequently in Klee's work. They have no definable meaning as such, and yet they speak their own particular 'language', both in terms of form and content. In this case the number 'forty-three', though probably chosen completely at random, does not function as a chance symbol, but as a necessary and meaningful sign.

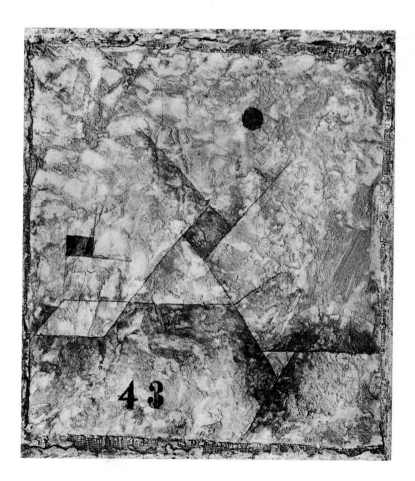

62
Nekropolis 1930
City of the Dead

Thick paste on packing paper, with an additional narrow strip attached at the bottom.
50.5×35.5 ($19\frac{5}{8} \times 14$)
Signed bottom right : Klee

In the winter of 1928-9 Klee travelled to Egypt. The experience of the journey along the Nile and into the archaic past is manifest in a series of works executed around 1930. Shrines, monuments, rows of tombs and hieroglyphs are combined in the various symbols and zones of this painting, reminders of the sunken layers of history which in turn correspond to the buried layers of human consciousness.

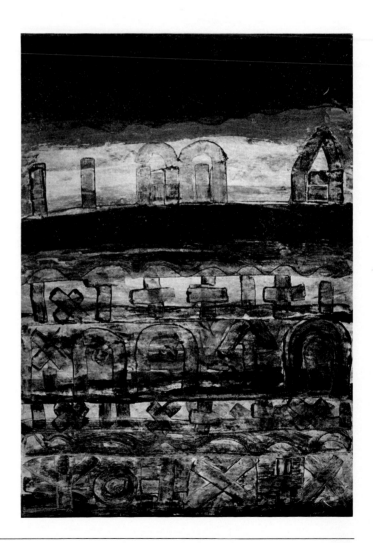

63
Gezeichneter 1935
The Marked One

Oil and water-colour on sized gauze mounted on cardboard,
30.5×27.5 $(12 \times 10\frac{7}{8})$
Signed bottom right : Klee
Signed and inscribed on back of frame : 1935 R 6. 'Gezeichneter'. Klee

It is tempting to think that this circle could have been a star, but it has become a human head instead. Thus Klee has left his strictly formal composition open to the possibility of figurative interpretation. He 'draws' a man, and this man is 'drawn' — by life, marked by fate and suffering.

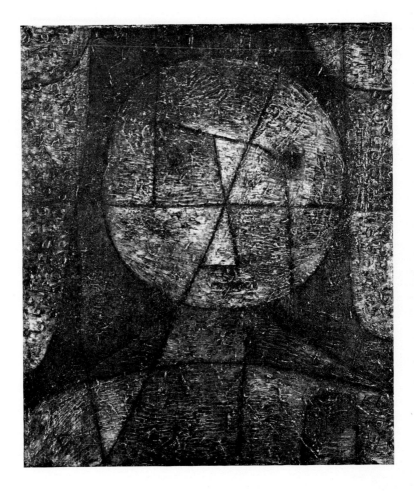

64
Schicksal eines Kindes 1937
A Child's Destiny

Pastel on light brown wrapping paper, 35×70 ($13\frac{3}{4} \times 27\frac{1}{2}$)
Signed on left : Klee
Signed and inscribed on cardboard lining : 1937 S. 20 Schicksal eines Kindes

An example of the symbolic, hieroglyphic language developed by Klee in his later years. It is far removed from the pictorial and anecdotal charm of his early period. With just a few lines he sketches the outline of a girl with innocent yet knowing eyes. Her 'destiny' is symbolized by means of letters and numbers. The blue mosaic of the background still employs the same planar structure that Klee developed under the influence of Delaunay during his visit to Tunis in 1914. In comparison with the patchwork quality of the earlier pictures, the structure has now acquired something of the character of a stained glass window with black leading between the panes.

65
Heroische Rosen 1938
Heroic Roses

Oil on primed jute, 68×52 (24¾×20½)
Signed top left: Klee
Signed and inscribed on back of frame: 1938. J 19. 'heroische Rosen' Klee

Klee had little sympathy for anything heroic and he ridiculed it frequently in paintings and drawings. Here again are the black symbols placed against a colourful mosaic background. Out of their midst comes a spiralling rose shape. In this case vegetation is not organic and passive in character, but a symbol of activity dictated by the will — the theme of many of Klee's late works.

66
Ohne Titel *c.*1939
Untitled

Body colour on paper, mounted on cardboard with a coloured border,
49.3 × 36.5 (19⅜ × 14⅜)
Signed top right : Klee

Subjects of this kind are close to the angels and demons which occur repeatedly
in Klee's late work. He outlines a figure with broad, graphic gestures : it could
be a human being, it could be a demon, it could be an angel or a crusader looking
vigilantly over his shield.

67
Tief im Wald 1939
Deep in the Wood

Mixture of tempera and water-colour on canvas primed with oil,
50×43 (19¾×17)
Signed bottom right : Klee
Signed and inscribed on back of frame : 1939 CC 14 'tief im im Wald' Klee

A painting of the greenness of nature with leaves and blossoms as primary forms,
as is nearly always the case in Klee's work. The title 'Tief im Wald' echoes the
forest green depths of the painting.

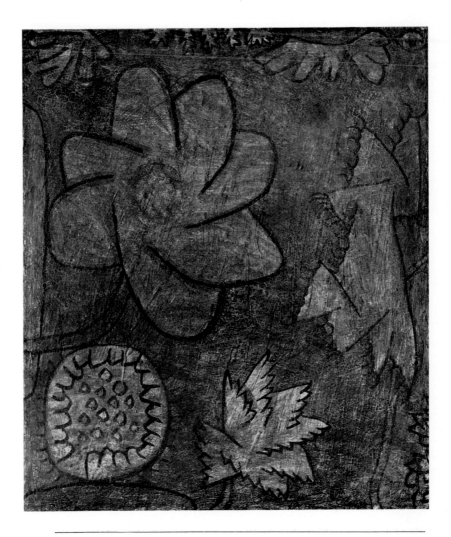

68
Untitled 1957

Oil on canvas, 200 × 158.5 (78¾ × 62⅜)
Signed bottom left: 57 KLINE

Franz Kline was one of the most significant painters in the group around Jackson Pollock which radically changed the face of American art in about 1950. Compared with Pollock's new conception of art, Kline's large canvas seems somewhat more traditional despite its forceful, even violent 'action'. The black brush strokes form a dynamic, though at the same time stable pictorial scaffolding. But here too the artist is prepared to risk releasing arbitrary impulses and chance reflexes, which he must either accept as legitimate pictorial elements or adjust accordingly.

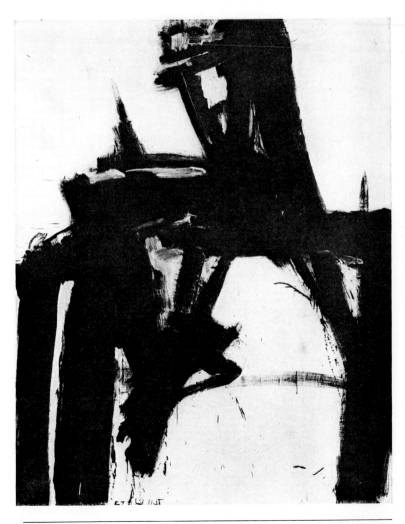

69
Selbstbildnis mit erhobenem Pinsel c. 1913-14
Self-Portrait with Raised Brush

Oil on canvas, 108.5 × 70.5 (42½ × 27¾)
Signed upper left : OK

This self-portrait is one of several which the artist executed in the last years be-
fore the First World War. As in all his early portraits it involves both a penetrating
analysis of the subject and of the pictorial means. The urgency of this confronta-
tion with his own ego is heightened by the compositional device of placing the
figure in empty space. Tintoretto, whose works had made a strong impression
on Kokoschka when he was in Venice shortly before this, also probably El
Greco, influenced the character of the painting both pictorially and intellectu-
ally. Kokoschka's allegiance to Expressionism cannot conceal the fact that he
was only minimally influenced by the major twentieth-century artistic discover-
ies of the autonomy of colour and form.

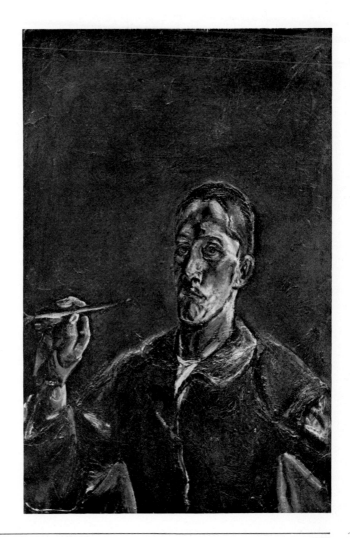

70
Contrastes de Formes 1914
Contrasted Forms

Oil on canvas, 80.7 × 65.2 (31¾ × 25⅝)
Signed bottom right: F.L. 14

In 1913 and 1914 Léger painted a series of pictures entitled 'Contrastes de Formes' in which he strove, along the same lines as Delaunay, to reconcile Cubism and colour. But whereas Delaunay tended towards soft tonal harmonies, Léger preferred bright primary colours reminiscent of the Fauves. In contrast to the Cubist tendency towards planar construction, Léger stresses the substantiality, the volume of the formal elements. But he models his characteristic tubular shapes by juxtaposing pure, contrasting colours. For all the abstraction, Léger's eye is always geared to reality. The metallic, tubular forms spark off associations with the machine age and modern technology, with the working world that fascinated him all his life.

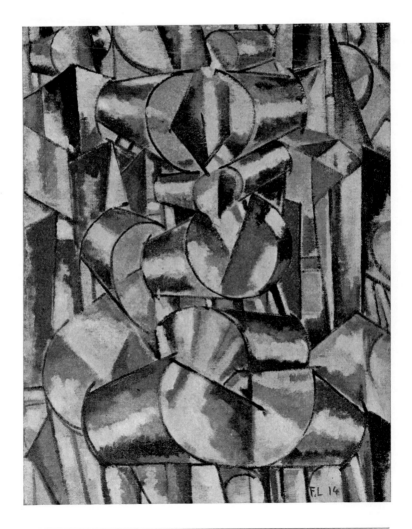

71
Le Soldat à la Pipe 1916
Soldier with a Pipe

Oil on canvas, 130×97 ($51\frac{1}{4} \times 38\frac{1}{4}$)
Unfinished oil sketch on reverse
Signed bottom right : F LEGER 16

The front in 1914 was an overwhelming experience for Léger. He painted 'Le Soldat à la Pipe' on leave in Paris in 1916. It is a painting of the trenches depicting man as the machine of war, in varying shades of grey on coarse brown canvas. However, Léger did not use a monochrome colour scheme for Cubist reasons, but simply to illustrate the grey misery of war. Though this picture paved the way for a later series of paintings of robot-like figures, the man here is not yet reduced to a state of total mechanization. The human element still penetrates the technological armour. The tubular forms developed in the 'Contrastes de Formes' paintings adapt themselves quite naturally to the forms of soldiers involved in mechanical warfare.

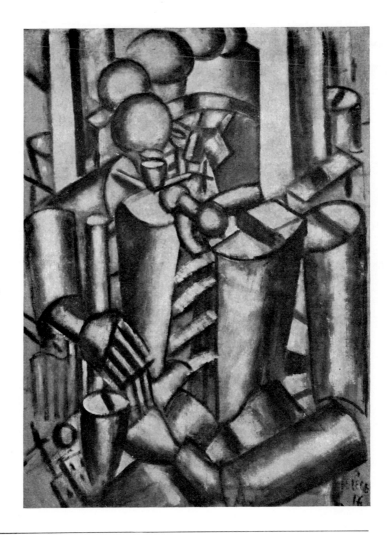

72

Femme tenant des Fleurs 1922
Woman holding Flowers

Oil on canvas, 73.3 × 116.5 (28$\frac{7}{8}$ × 45$\frac{7}{8}$)
Signed bottom right : F. LEGER 22
Signed and inscribed on reverse : femme tenant des fleurs F LEGER 22

In 1922 Léger painted this picture of two women as a kind of 'Olympia' (Manet) in the spirit of the early 1920s with its trend away from the individual towards the anonymous and the collective. The forms of the women's arms, legs, breasts and necks echo the tubular forms of the 'Contraste de Formes'. But the two are separated by the period of his machine paintings, and it is the cold formal language of the latter which now fuses with the human and organic elements. Hence the faces gazing, so it seems, both inward and outward ; waiting in silence, yet seemingly suppressing a question. Léger's aim was totally unsentimental ; he wanted to give man the same rank as, and no higher than, the other objects in the picture. Motifs from this painting, which marks the beginning of Léger's great monolithic figure style, appear again and again in his subsequent work.

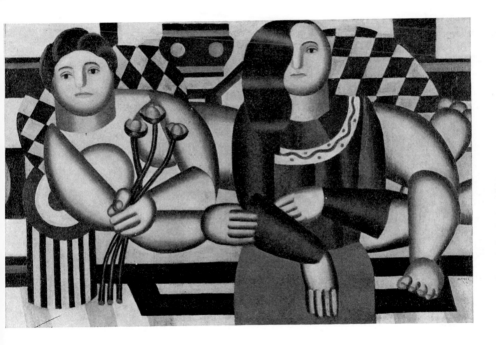

73
Adam et Eve 1935-9
Adam and Eve

Oil on canvas, 228× 324.5 (89¾× 127¾)
Signed bottom right : F. LEGER. 35-39
Signed and inscribed on reverse : F. LEGER – 1935-39 ADAM ET EVE

Léger aimed at a monumental style, but he did not seek it through the relation of geometrical forms to a flat surface ; instead, he turned to the human figure. One of his most impressive works of the thirties is this large painting from his acrobat series which he entitled 'Adam et Eve', though it is not immediately obvious that it depicts more than a pair of acrobats. As usual, certain features and even whole areas of the composition can be found in other works of the same period. It dates from a time when Léger was extremely busy with commissions for murals and stage designs. The monumentality of the composition is combined with a high degree of human gracefulness and poetry – though it strictly avoids any sentimental overtones, a fact which is further intensified by the plebeian solidity of the figures.

Reproduced in colour on p. 17

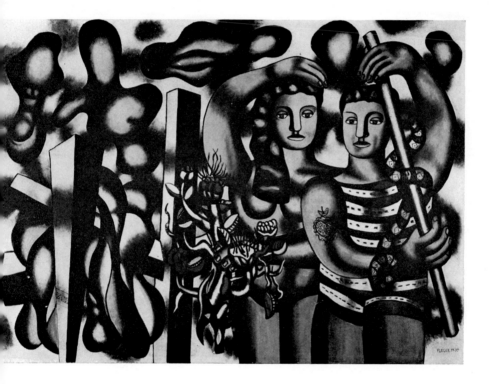

74
Big Painting No. 6 1965

Oil and magna on canvas, 233×328 ($92\frac{1}{2} \times 129\frac{7}{8}$)
Signed on reverse : Roy Lichtenstein 1965

Lichtenstein's great theme is reality. To be more precise, American reality – the reality of consumer goods and supermarkets, of advertising and strip-cartoons. In this picture he has taken for his subject-matter a few brush-strokes, the most banal and self-evident elements of all painting, and has sim-plified them, treated them with irony, and yet succeeded in monumentalizing them. The passionate dynamism of the brush-stroke is rendered quite dispas-sionately and undynamically, indeed with the greatest graphic skill, and a com-plete denial of the expressive manual quality of the brush. These are not real fluid brush-strokes painted on canvas, but a frozen image of them. And this in turn is symptomatic of a certain development in American art. By painting a completely motionless version of the energetic expressiveness of Action Paint-ing, Lichtenstein vanquishes the style through irony. The formula-like 'objecti-fication' of something of an essentially subjective nature is further emphasized by the mechanical screen-stencilled dots of the background.

Reproduced in colour on p. 18

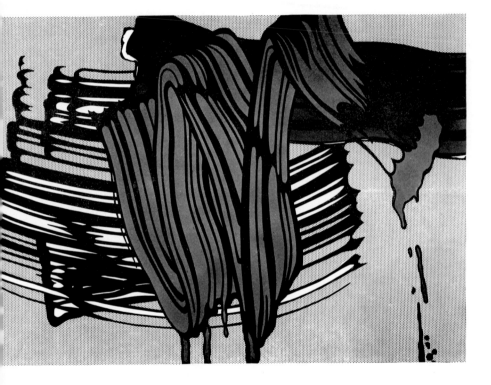

75
Proun G 7 1923

Distemper, tempera, varnish and pencil on canvas, 77×62 ($30\frac{3}{8} \times 24\frac{3}{8}$)
Unsigned

Around 1920 a rich, multi-faceted avant-garde art was developing in the youthful Soviet Union, influenced by the artistic upheavals in the West, and spurred on by the hopes roused in many intellectuals and artists by the October Revolution. El Lissitzky was the most important figure apart from Malevich in the Russian Constructivist movement. He painted this picture in 1923 during a two-year stay in Germany. It is a rationally constructed composition, though its rationalism does not conceal the Utopian desire which makes the proportions seem so artistic. The word 'Proun', which Lissitzky coined as a general title for his experimental work, is a cryptogram formed by combining the prefix 'Pro' with the initial letters of the Russian words for 'establishment of new forms in art'.

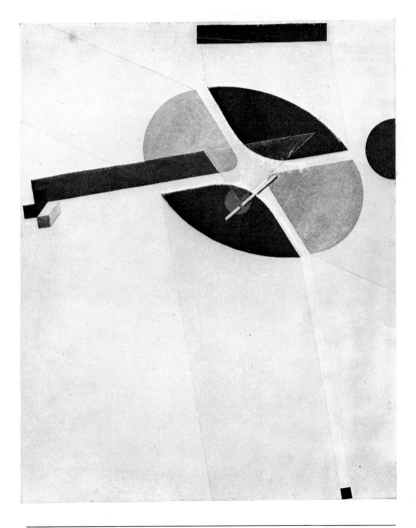

76
Gamma Gamma 1959-60

Acrylic paint on canvas, 260 × 386 (102$\frac{3}{8}$ × 151$\frac{3}{8}$)
Signed on reverse : M. Louis 390

Colour streams in diagonal tracks across both the lower corners of the canvas The irregularity of the currents and their precision of form in spite of this is, effected without any imaginative interference on the part of the artist. The colour unfurls according to its own laws. The artist has rigorously avoided any hint of intervention in the way the paint is applied. The acrylic paint has been diluted with turpentine and is easily soaked up by the canvas : it colours the canvas, saturates it, becomes part of it. Thus the streams of colour dispense with any kind of imposed structure. They are pure uninhibited process a process which also determines its own contours. Between the colour areas on the huge canvas the artist has left an extensive space 'empty'. But this potentially negative zone involuntarily takes on the positive quality of spaciousness. The effect is also very much a result of the scale of the painting.

77
Der Kleine Himmel 1968-69
Little Heaven

Aluminium, perspex and wood, 150×200×5 (59×78¾×2)
Not inscribed

An important place within the so-called Op Art of the sixties is occupied by the
Düsseldorf Zero group formed towards the end of the fifties, with considerable
international participation, around Heinz Mack, Otto Piene and (somewhat
later) Günther Uecker. Zero was a catchment area for a number of different artis-
tic directions. It included artists of 'Nouveau Réalisme' like Tinguely and
Spoerri whose adherence to decaying, discarded material was countered by the
Düsseldorf artists, under the influence of Lucio Fontana and Yves Klein, with
the idea of artistic purity and purity of artistic idea: a 'Nouvel Idéalisme', as it
was sometimes called. It is significant that the idea of purity of light and of its
immaterial and spiritual qualities as reflected in the work of art, fitted in easily
with certain material elements: the gleaming metal surfaces used by Mack,
Piene's fire processes and Uecker's fields of nails.

78

Kathedrale zu Freiburg in der Schweiz 1914
Cathedral at Freiburg in Switzerland

Oil on canvas, 60.6 × 50.3 (23⅞ × 19⅞)
Unsigned

In 1912 August Macke and Franz Marc visited Delaunay in Paris. In 1913 Macke was host to Delaunay in Bonn, and in 1914 he made his momentous visit to Tunis with Klee, the same year in which he executed this cityscape. Delaunay's influence is less directly noticeable in Macke's work than in Klee's, for Macke absorbs figurative elements and the illusion of volume and space into a patchwork of colour to a much smaller extent. The basic geometric forms and their fine gradations of colour seem to belong as much to the actual world as to the pictorial one: motif and pictorial means are in open harmony with each other.

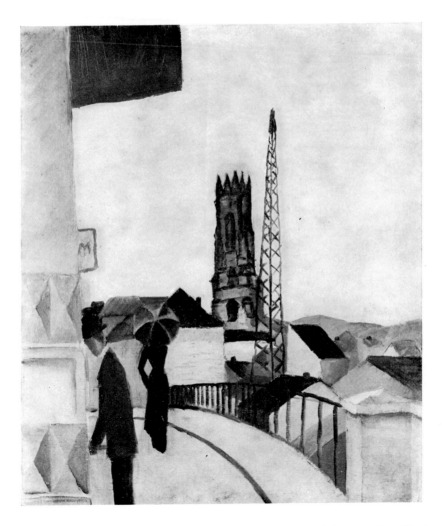

79
Le Plaisir 1926
Pleasure

Oil on canvas, 74×98 ($29\frac{1}{8} \times 38\frac{5}{8}$)
Signed bottom right : Magritte

This painting dates from Magritte's earliest period of creativity in 1925-6. En-
titled 'Le Plaisir', it depicts a young girl biting into a live bird, spattering blood
all over the white collar of her tidy dress, though showing no signs of
pleasure or displeasure in the act. The murderous event is devoid of any feeling
of drama ; neither the protagonists nor the handling of paint display the slightest
emotion. Yet this is precisely what creates the 'surreal' effect. The motionless-
ness and innocence of the picture strengthen the sense of horror. The scene can
be interpreted as a secular version of original sin in which a very bourgeois Eve
in a paradisical setting eats a forbidden bird rather than a forbidden apple,
staining her childlike innocence in the process as much as her childlike collar.

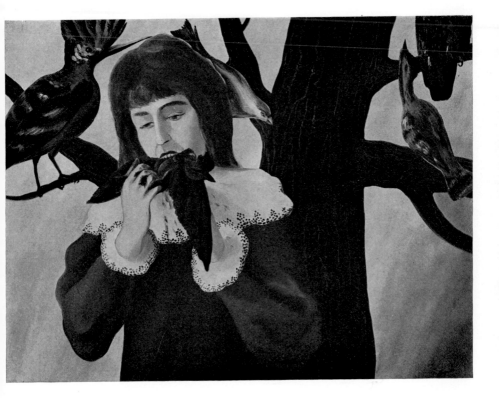

80

La Rencontre 1926-7
The Meeting

Oil on canvas, 139.5 × 99 (54$\frac{7}{8}$ × 39)
Signed bottom left : Magritte

Magritte began to use the motif of balustrade posts as early as 1926 and they occur frequently in his work from that time on. In this instance they are the protagonists in a meeting of two groups of three figures in a theatrically romantic setting. The tradition of this kind of painting goes back to Italian Pittura Metafisica which suggested associations between heterogeneous elements from the real world and – through the enigmatic mood of these juxtapositions – everything in existence. Ordinary things presented just as they are are made to symbolize the great mysteries of life. In Magritte's work this happens in the most inventive and confusing ways: he successfully destroys the equilibrium of the rational world through uncomfortable combinations of objects, by physically altering objects and figures and by an oppressive sense of derangement and deformation.

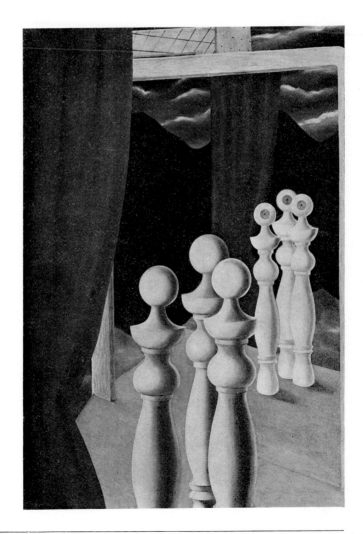

81

La Masque Vide 1928-9

The Empty Mask

Oil on canvas, 73 × 92.5 (29¾ × 38⅜)
Signed bottom left : Magritte

This painting is divided into four irregular sections. Though a real object in the fullest sense, it is transformed into an intellectual concept in the simplest way imaginable : Magritte did not paint visual images in each of the four compartments, instead he inscribed them with the words 'sky', 'human body (or forest)', 'curtain, and 'house-front'. In this sense the picture is simply concerned with the intellectual side of its existence. On the other hand, however, one can say that Magritte has painted this picture, in that it is a picture, within a picture. It is not the painting itself that is conceptual but the picture that it portrays. Through works such as this Magritte can be seen as the precursor of today's 'Conceptual Art' where concepts take precedence over objects.

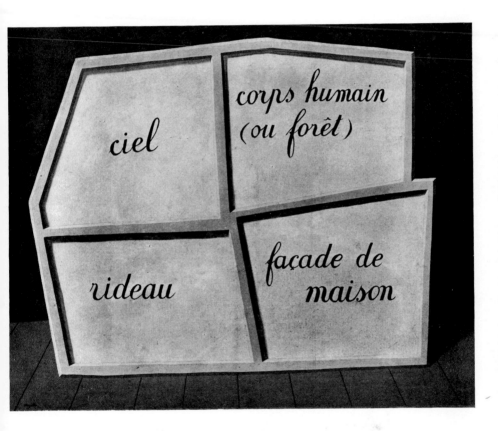

82

Nuit de Gethsémani 1952
Night at Gethsemane

Oil on canvas, 198 × 148 (78 × 58¼)
Signed bottom right : Manessier 52

Alfred Manessier exploits every possible pictorial means to achieve the stained glass effect of this picture in which the influence on French painting of Klee's late work is evident. 'Passion' in both the religious and the emotional sense forces colour and form way beyond the level of the purely decorative, though it is precisely Manessier's decorative strength which make his work so well suited to archetectonic treatment, particularly in this church window form.

83
Drei Katzen 1913
Three Cats

Oil on canvas, 72×102 (28$\frac{3}{8}$×40$\frac{1}{8}$)
Signed bottom right: M

Animals are at the hub of Franz Marc's artistic philosophy, especially animals in the context of their natural destiny. In the three cats in this picture, for example, he has portrayed three highly individual yet absolutely typical animals and the forces of tension that exist between them. They symbolize the tensions between men and women, between the conqueror and the conquered. These tensions are rendered explicit by the formal and chromatic framework of the picture, an abstract composition with a transparent diagonal structure clearly influenced by Futurism and Delaunay. The ambivalent way the interwoven forms of the animals' bodies both contribute to and assert themselves over the formal energy of the composition makes us sharply aware of the simultaneous captivity and freedom that is the destiny of animals within nature as a whole.

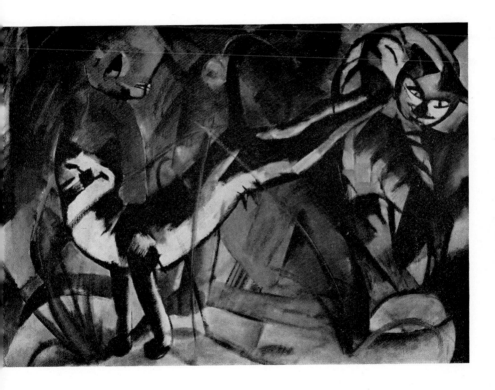

84

Intérieur Rouge, Nature Morte sur Table Bleue 1947
Red Interior, Still Life on a Blue Table

Oil on canvas, 116 × 89 (45⅝ × 35)
Signed bottom right : H. MATISSE 47
Signed on reverse : HM

Between 1946 and 48, when he was almost eighty years old and after a serious illness, Matisse was able to paint one more series of masterly oil paintings before his health allowed him to work only with scissors and paper. Together with the 'papiers découpés' done in the final years of his life, these late pictures are his last major works. With the greatest freedom — though it was no longer a freedom that needed to assert itself — he explored yet again the methods of expression that he had evolved and tested over the years. These pictures speak a language which is both subtle and uniquely simple. There are many bold features in the picture — the black zig-zags on the red ground, the flattening of space, the abruptness of the view into the garden, the vase of flowers looking like a paper cut-out, the medallion on the wall. Yet they do not strike the spectator as particularly daring, rather as a matter of course in an art which extracts the utmost from the most economical means.

Reproduced in colour on p.19

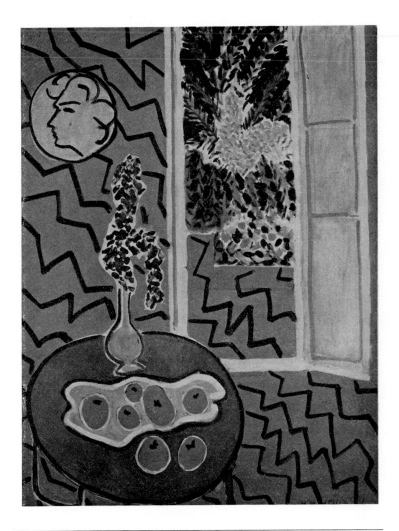

85
Nu au Miroir 1919
Nude with a Mirror

Oil on canvas, 113 × 102 (44½ × 40⅛)
Signed top left : Miró. 1919

After a period of Fauvist-Expressionist painting – tempered however by the influence of the Mediterranean – Miró began painting landscapes in the deliberately naive realistic style which culminates in the monumental 'Farm' of 1921-3. At the same time he also worked on portraits, still-lifes and nudes. In 'Nu au Miroir', as in other paintings of the same period, realism is heightened by means of the delicate and subtle calligraphic style which in turn gives a flavour of unreality. The effect is enhanced – as in Chagall's work – by a leaning towards Cubism, though Miró misinterprets it as a 'method' in the interests of his own art. To this he adds a Mediterranean order and wit. Just as Beckmann drew heavily on late medieval German art, Miró took his inspiration from the South European Quattrocento. And finally there is the artist's own especial sense of humour which is confirmed by every line he draws and makes him seat the girl on that florid bourgeois bedroom stool.

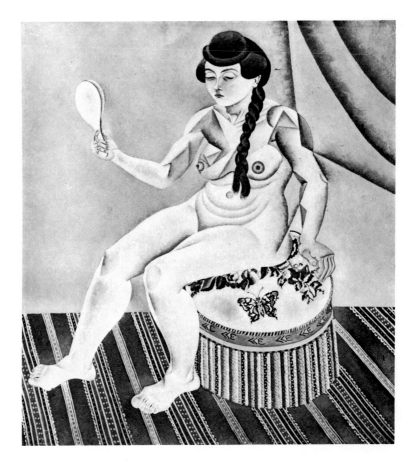

Joan Miró b.1893

86
Etoiles en des Sexes d'Escargot 1925
Stars in Snails' Sexes

Oil on canvas, 129.5 × 97 (51 × 38¼)
Signed bottom right : Miró. 1925.
Signed on reverse : Joan Miró. 1925.

This almost monochrome brown painting could be seen as a direct pictorial interpretation of André Breton's doctrine of 'psychic automatism' and the 'écriture automatique' driving from it – in other words, the spontaneous act of painting according to the dictates of the subconscious. The whimsical poetic title Miró gave this work, 'Etoiles en des Sexes d'Escargot', is in keeping with other pictures of the period which incorporate verses, or words, or just letters or numbers, and which he himself called 'tableaux-poèmes'.

Joan Miró b.1893

87
Personnages Rythmiques 1934
Rhythmic Figures

Oil on canvas, 193 × 171 (76 × 67¾)
Unsigned

Various anthropomorphic and zoomorphic figures have assembled for a dance
beneath the sickle moon. The picture does not come to life simply because of its
Surrealist content or even because of the 'psychic automatism' of the drawing ;
its lively effect is due overwhelmingly to the rhythms created by the colours and
forms. It was in fact conceived as a design for a tapestry, which in itself places it
outside the Surrealist way of thinking. The humour too is somewhat un-Surreal-
ist : the whole composition is pervaded by a relaxed and naive cheerfulness.

Reproduced in colour on p. 20

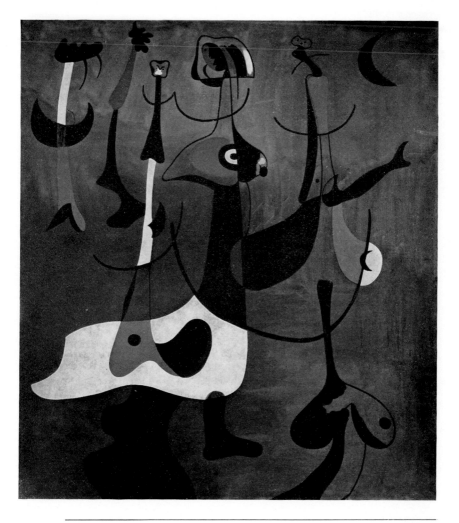

Joan Miró b.1893

88
Femmes et Oiseaux dans la Nuit 1945
Women and Birds in the Night

Oil on canvas, 114.5×146.5 (45⅛×57¾)
Signed and inscribed on reverse: Miró. 12-2-45 'femmes et oiseaux dans la nuit'

In 1945 Miró painted a number of pictures with white backgrounds, inhabited by birds, stars, fantastic figures and freely invented shapes. In this work, too, the light-hearted pictorial anecdote is not merely illustrative, but has the status of a full-scale pictorial statement. The figures and shapes are neither more nor less than spontaneous interpretations of autonomous forms.

89
Caryatid *c.*1911–12

Oil on canvas, 72.5 × 50 (28½ × 19¾)
Unsigned

The strict, formal composition of this picture is inconceivable without Cubism —
not least as far as the monochrome colouring is concerned. However the figure
has merely been simplified, not faceted in the Cubist manner. There can be no
doubt that in addition to Greek and Khmer sculpture Modigliani was also in-
spired by the Negro sculpture then being 'discovered' by many artists. But it was
the sculptor Constantin Brancusi, to whom he was especially close at this time,
who encouraged Modigliani to start making sculpture himself. The caryatid
was a theme which fascinated him for many years and he explored it in sculp-
tures, paintings, watercolours and drawings.

90

Portrait of Max Jacob 1916

Oil on canvas, 73×60 (28⅜×25⅝)
Signed bottom right : modigliani en 1916
Inscribed upper left- and right-hand corners :MAX [and] MAX JACOB

The influence of Negro sculpture can also be seen in this portrait of the poet Max Jacob, in the shape of the face and in the way the nose looks as if it has been hewn with an axe. It is one of an extensive series of portraits of the poets, painters, sculptors and art dealers Modigliani counted among his friends in Paris. It evokes the legendary world of Montparnasse that will always be associated with him.

91

Composition with Yellow Spot 1930

Oil on canvas, 46×46.5 ($18\frac{1}{8} \times 18\frac{1}{2}$)
Signed bottom right : PM 30
Signed on back of frame : PIET MONDRIAN

This painting dates from the artist's mature period when the rich colours of his early works had given way to a more ascetic approach. Except for one small yellow rectangle the entire picture surface is white, articulated only by a series of black horizontal and vertical lines which avoid any suggestion of space even where they intersect. The meditative lyricism of this picture is hard to define in the face of the unassailable strength of the strict geometric composition. For Mondrian regarded geometry not as a mathematical discipline, but as a law of the human intellect and of cosmic order. It is this idealistic justification that lends his pictures their primary intellectual quality.

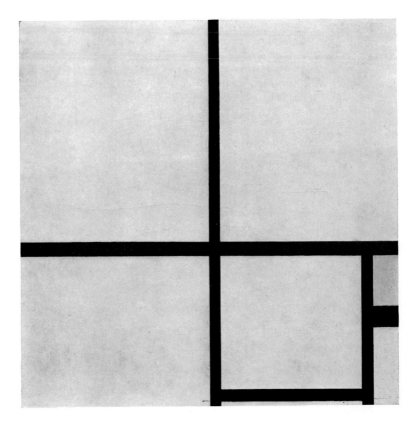

92
Vertical Composition with Blue and White 1936

Oil on canvas, 121.3×59 (47¾×23¼)
Signed bottom right: PM 36
Signed and inscribed on back of frame: M I P MONDRIAN Composition (blanc et bleue)

This tall oblong format is common to only a few of Mondrian's paintings at this time. It recalls the decisive verticality of his early tower paintings of 1909-10 which he was probably consciously readopting. Here again we have an extreme asceticism of colour: white areas divided by black diagonal and vertical lines, with a small blue rectangle at the top right-hand corner which counterbalances the otherwise predominantly vertical emphasis.

92

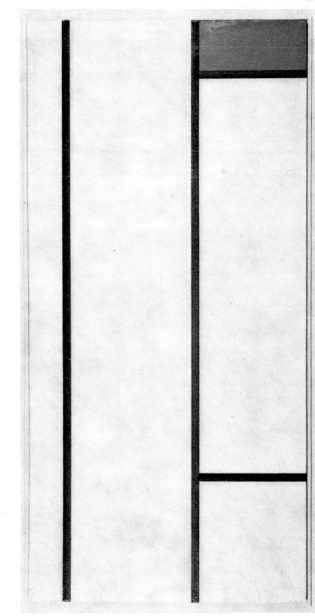

93
Rhythm of Black Lines 1935-42

Oil on canvas, 72.2 × 69.5 (28½ × 27⅜)
Signed bottom right : PM 35 42
Signed and inscribed on back of frame : PIET MONDRIAN - '37-'42

Nothing could have been further from Mondrian's mind than to allow external visual experiences to enter his geometric, icon-like paintings. But it is not doing him an injustice to see a connection between works such as this composition of 1935-42 with its grid of black lines and modern architecture, which after all interested Mondrian all his life, as did urban design, for example the severely rectangular layout of Manhattan Streets. Indeed at this time he gave many of his pictures names like 'Place de la Concorde' and 'Trafalgar Square', and in 1942-3 he painted the large work entitled 'New York City' in which he relinquished black lines for the first time. But despite references of this sort he was at no point interested in creating abstract images of the objective world ; what really concerned him was the autonomous, concrete reality of the picture itself through which he strove to attain the absolute harmony that is the expression of universal truth.

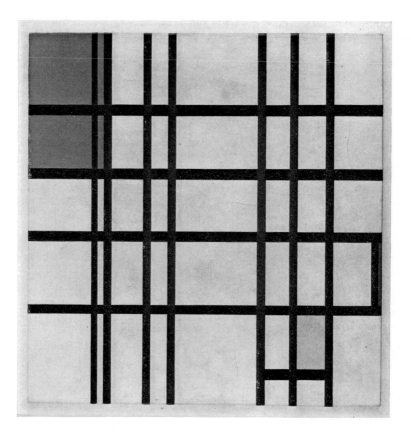

94
Natura Morta (Il Vaso Blu) 1920
Still Life (The Blue Vase)

Oil on canvas, 49.5 × 52 (19½ × 20½)
Signed bottom left : Morandi 920

Like the works of de Chirico and Carrà, Giorgio Morandi's still-lifes of 1916-19 belong in the context of Pittura Metafisica. This painting done in 1920 is typical of the next phase of his artistic development. The objects no longer appear in meaningful isolation within an airless space ; they now seem encompassed by paint and by light. Unlike most of his other paintings, this work is not based on an actual arrangement of objects but on a still life by Cézanne. And it was through the example of Cézanne that Morandi found a way out of Pittura Metafisica.

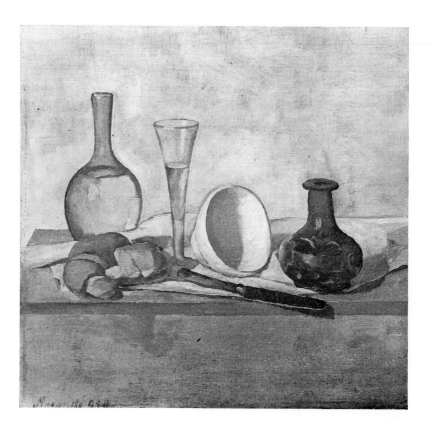

95

Natura Morta (Tazze e Barattoli) 1951
Still Life (Cups and Pots)

Oil on canvas, 22.5 × 50 ($8\frac{7}{8} × 19\frac{3}{4}$)
Signed bottom centre left : Morandi

From about 1920 to the end of his life the identity of colour and light remained the fundamental theme of Morandi's work. Over and over again he recorded the constantly changing effects of light and colour on the same group of objects. This 1951 still life pays homage to colour that has been transformed into light and light that has become colour. There is an especial magic in the way he has arranged objects of the same height in almost parallel rows, in direct contrast to the classical organization of the earlier picture.

95

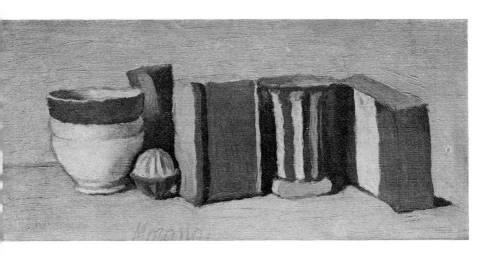

96

Zirkelzeichen 1961

Circular Signs

Oil on canvas, 200×120 (78¾ × 47¼)
Signed bottom right : NAY 61
Signed on reverse : NAY
Signed and inscribed on back of frame : NAY - 'ZIRKELZEICHEN' - 1961

In Germany Abstract Expressionism could form a direct link with its own Expressionist past. And, due to the fact that it had been suppressed by the Nazis for almost two decades, Expressionism enjoyed a considerable revival of interest after 1945. It was therefore no coincidence that it should have been German artists like Hartung and Wols who inaugurated the Abstract Expressionist movement, even though they were living outside Germany at the time. Ernst Wilhelm Nay's early work was directly indebted to Expressionism until he developed his own personal kind of Abstract Expressionism in the mid-1950s. In 1955 he painted his disc pictures in which he aimed to 'traverse the surface choreographically' with circles of pure colour. In the course of the fifties Nay's impetuous artistic temperament became increasingly evident in these 'chromatic' paintings, until the discs were finally replaced by violent swirls of paint.

97
Dec 1965 Amboise 1965

Painted relief on hardboard, 187 × 122 (73⅝ × 48)
Signed and inscribed on reverse : Ben Nicholson Dec 1965 (Amboise)

Nicholson's geometric approach is totally different from that of Piet Mondrian who was twenty years his senior. Between the wars Nicholson followed the general trend towards geometry, though without committing himself to it outright as Mondrian had done. Nicholson treats geometry in a relative way, for he has always permitted figurative elements in his pictures and combined strict geometry with a sensuous painterly surface. He thus 'humanizes' the merciless laws of geometry, though without surrendering its dignity. It would be more precise to call his art metric than geometric, for though proportion is paramount it is far removed from any thought of mathematics.

98
Swing 1964

Acrylic on canvas, 251 × 249 (98½ × 98)
Signed and inscribed on reverse : 'SWING' 1964 Kenneth Noland

To ensure objectivity in its chromatic development and self-expression, the colour is completely impersonal in handling. Its concern is to describe nothing beyond itself, its own existence. This return to colour as an objective fact in its own right has connections with the contemporary return to geometry, and Josef Albers' theories can be seen to have influenced a younger generation. In this picture, however, geometry is also subordinated to colour. For the square achieves its dynamic effect not only through its position on the canvas, but above all by means of the bands of colour. Though the edges follow the dictates of geometry, they are nevertheless allowed a certain amount of artistic licence. The resulting effect of spaciousness and freedom - quite unlike anything in Mondrian - transcends the hermeticism of geometry. Noland's painting expresses with great clarity this intellectual ambivalance of freedom and obligation.

99

Frauen und Pierrot 1917
Women and a Pierrot

Oil on canvas, 100.5 × 86.5 (39⅝ × 34)
Signed top right : Nolde
Signed and inscribed on back of frame : Emil Nolde : 'Frauen und Pierrot'

Despite the title, the subject of this picture is not really the circus with its fleeting and picturesque effects. The essential theme is 'woman' in the original, primitive and barbaric sense, echoing Nolde's voyage to the South Pacific in 1913-14. 'Spiritualization' is not seen here as a force opposing the world of the senses (so often the case in Nolde's work), but as the force enabling the sensual world to express its most fundamental aspects. Artistic sensualism corresponds directly to physical sensualism, thus the expressively heightened colour of the women's bodies is placed against the contrasting blue-white foil of the pierrot.

100

Portrait of Fernande 1909

Oil on canvas, 61.8 × 42.8 (24⅜ × 16⅞)
Signed top left : Picasso

In 1907 Picasso painted 'Les Demoiselles d'Avignon', the epoch-making pic-
ture that introduced the dissection of the object for the sake of form. In 1908
Braque painted his L'Estaque landscapes. In 1909 Picasso spent the summer
in Horta de Ebro, where, in addition to some strictly Cubist landscapes he
executed a series of portraits of his current girl-friend, Fernande Olivier. The
powerful influence of Cézanne is unmistakable, both in the treatment of colour
and with reference to Cézanne's famous dictum that all natural forms are built
up from the basic stereometric forms of the sphere, the cone and the cylinder.
Picasso proceeds to analyse the head and the vase of flowers in the back-
ground as if following this maxim. Nevertheless, despite the methodical break-
down of forms the picture still bears the full imprint of the artist's personality.

101
Nature Morte, Bouteille et Verre 1912
Still Life with Bottle and Glass

Collage, charcoal and oil on canvas, 62 × 48 (24⅜ × 18⅞)
Signed on reverse : Picasso

The years 1911 and (particularly) 1912 saw the introduction of the Cubist collage and with it an important chapter in the history of modern art. Compared with many of Picasso's other collages, this one is eminently pictorial in character. Its elements are of cuttings from the *Figaro*, pieces of vulgar patterned wallpaper, other pieces of paper cut in the shape of objects, and finally pencil lines. It is characteristic of Picasso's economical approach that the following page of the same edition of *Figaro* appears in a collage belonging to the Tate Gallery.

102
La Guitare 1913
The Guitar

Oil on canvas, 116.5 × 81 (45$\frac{7}{8}$ × 31$\frac{7}{8}$)
Signed bottom centre : Picasso

Here too we have a collection of the typical elements of a Cubist still life : a table, musical instruments and a bottle. But the picture in fact consists of a number of large, clear, autonomous areas of colour, and the chromatic effect is surprisingly similar to that of his Pink Period of 1905. In this work Picasso has come (for him) unusually close to the boundaries of abstraction. However, the paintings of the following years are once more full of naturalistic elements.

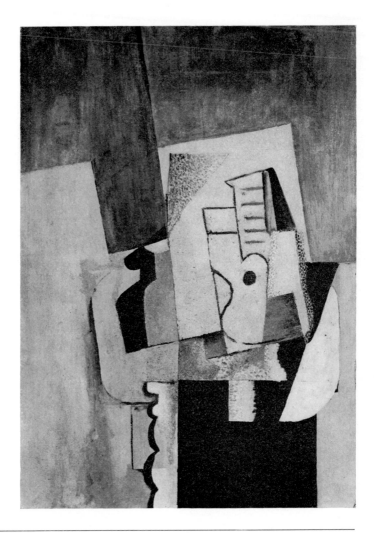

103
Fenêtre Ouverte 1919
Open Window

Oil on canvas, 209.5 × 117.5 (82½ × 46¼)
Signed bottom centre : Picasso 19

Picasso spent the summer of 1918, immediately after the end of the war, in St. Raphael on the Côte d'Azur. The theme that occupied him during this period – mostly in drawings and water-colours – was a table covered with objects set in front of an open window. His approach exploits the tension between the vast implications of abstraction and the new naturalism which is beginning to assert itself in his work at about this time. In the autumn of the same year he took up the theme again and produced this tall narrow painting. Echoes of Cubism are evident even though the Cubist devices, especially that of quasi-collage, are now handled with greater freedom and mastery.

Pablo Picasso 1881-1973

104
Deux Femmes Nues Assises 1920
Two Nude Women Seated

Oil on canvas, 195×163 ($76\frac{3}{4} \times 64\frac{1}{4}$)
Signed bottom right : Picasso 20

In the early 1920s Picasso developed the monumental figure style of his 'classic' period. This was inspired initially by his collaboration with Diaghilev's Ballet Russe which he accompanied to Rome and Pompeii in 1917. Picasso's work had always been open to the possibilities of classicism, both stylistically and thematically. It became apparent for the first time during his 'Iberian' period of 1905-6, immediately preceding Cubism. The nudes of that period already manifest the combination of classicism and the somewhat less classical pre-dilection for the gigantic human body which subsequently came to the fore again in much of his work around and after 1920. This 1920 painting of 'Deux Femmes Nues Assises' stands at the beginning of this period and is one of its most important works. The imaginary relief space is almost burst asunder by the Michelangelesque force of the enormous female bodies. They are like women from a race of Titans, weighty in build and thought, Amazons in a setting of Spartan simplicity. They are drawn from sources ranging from the academic to the mythical. And the overall mood of the picture also covers a wide range, from the massive strength of the figures with their ponderous hands to the meditative quiet of the woman with her head propped on her hand, from a distance reminiscent of Dürer's 'Melancholia'.

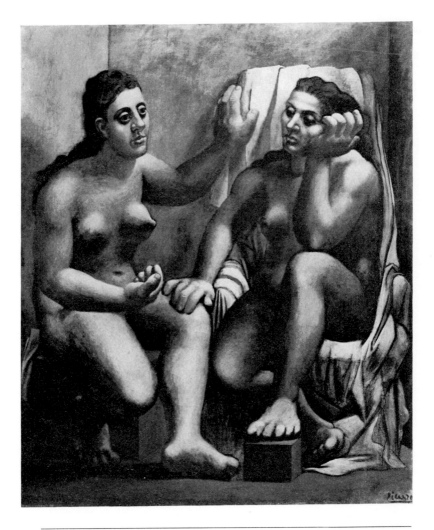

Pablo Picasso 1881-1973

105

Nu Assis 1933
Seated Nude

Oil on canvas, 130 × 97 (51¼ × 38¼)
Signed bottom left : Picasso 33
Signed on back of frame : Picasso 20 Février M.CM.XXXIII

Given Picasso's intellectual and artistic temperament it is hardly surprising that he should have been fascinated by the spectacle of Surrealism in the later 1920s. However, it was not the dogma of the Surrealists that stimulated him so much as the fantastic and absurd forms they created – in such marked contrast to the classical quiet of his own art at the beginning of the twenties. Among his 'Surrealist' works is a series of paintings and drawings containing sculptural figures executed between 1927 and 1937. With such openly declared sculptural interests it seems strange that no comparable forms are to be found in his sculpture itself at that time. This large painting of 1933 depicts a female nude whose individual parts are conceived as round or curved volumes. Despite the ruthless deformation and contrivance of form the figure has an air of great sculptural composure : Picasso's classicism pervades even this new disjointed approach.

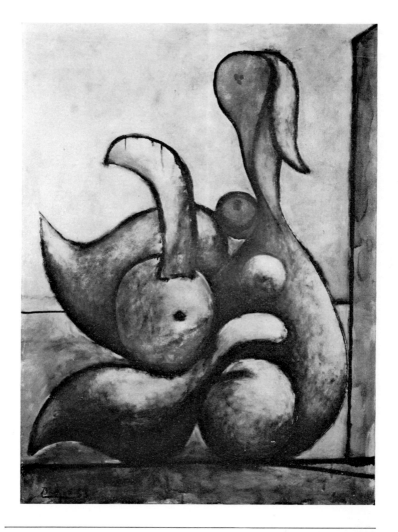

106
Femme au Miroir (Femme Accroupie) 1937
Woman at the Mirror (Woman Crouching)

Oil on canvas, 130×195 ($51\frac{1}{4} \times 76\frac{3}{4}$)
Signed bottom right : Picasso 16.2.37

The Spanish Civil War was the first outbreak of the storm that was to culminate in the Second World War. In February 1937, shortly before starting work on the preparatory studies for 'Guernica' Picasso painted this large picture of a woman crouching on the floor gazing intently at a drawing. It is apparently uninfluenced by events in Spain, though it does have a certain Andalusian flavour. It was preceded by a group of paintings entitled 'Deux Femmes' made in 1935-6. They depict a woman squatting in the foreground sketching, while another woman leans over a table, on which there is a vase of flowers. Near them is a large mirror. The 'Femme au Miroir' of 1937 stands apart from the expressive intensity of the earlier pictures in its atmosphere of pictorial calm and meditative introspection.

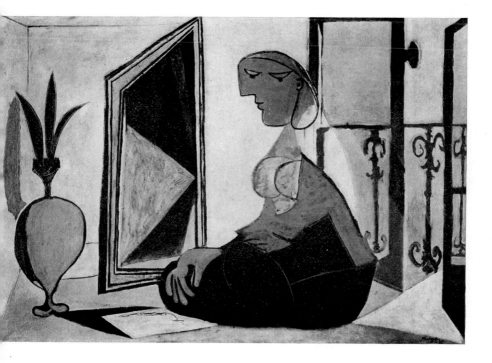

107
Femme Assise dans un Fauteuil, 12 Octobre 1941
Woman in an Armchair

Oil on canvas, 80.7 × 65 (31¾ × 25⅝)
Signed bottom left : Picasso

The shock of the Spanish Civil War caused Picasso to revert to the Cubist frag-
mentation of figures and objects but he now exploited it for its intensely expres-
sive qualities. This strikes the note for Picasso's approach throughout the years
leading up to and during the war. The same violence, the same ruthlessness
towards natural forms characterises 'Femme Assise dans un fauteuil' which he
painted during the German occupation of Paris in 1941. It is the forerunner of a
long series of important portraits – predominantly of his friend, Dora Maar.

Reproduced in colour on p. 21

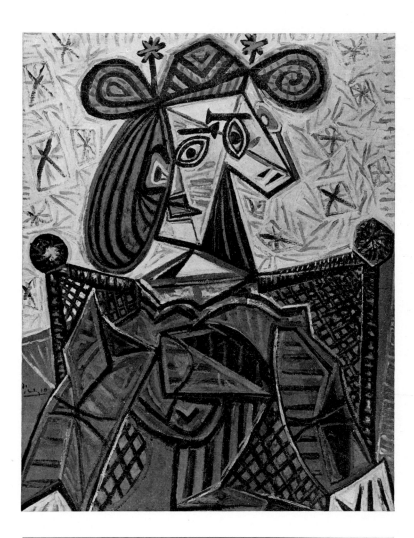

108
Nature Morte au Crâne de Boeuf 1942
Still Life with an Ox Skull

Oil on canvas, 130 × 97 (51¼ × 38¼)
Signed bottom right : Picasso
Inscribed on reverse : 5. Avril 42.

This 'Nature Morte au Crâne de Boeuf' executed the following spring is entirely unaggressive, subdued in technique, colour scheme and composition, though a more vehement version preceded it by a couple of days. Picasso painted this picture a week after the death near Paris of the Spanish sculptor Julio Gonzalez, who had been a friend for many years and had helped Picasso when the latter was working on a series of metal sculptures between 1929 and 1931. The still-life was intended as a requiem for his death. Ceremonially, as if lying in state, the bull's skull lies on the dark table fragmented in the Cubist manner. The skull is the symbol of death, while the bull — as so often in Picasso's work — is a symbol of the Spanish people.

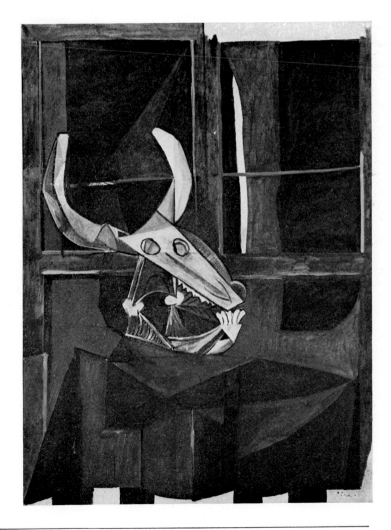

Pablo Picasso 1881-1973

109
Grand Profil 1963
Large Profile

Oil on canvas, 130×97 (51¼×38¼)
Signed top left: Picasso
Inscribed on reverse: 6.1.63

This portrait was executed when Picasso was over eighty years old, yet it is painted with incomparable skill. It shows a female idol of our time — classical and contemporary at once. Picasso painted it, and numerous other female portraits, in his studio at Mougins in 1963. In many ways it recalls his bronze busts of 1932: there is the same elongated neck, the same sideways-glancing eye, the same powerful nose. The legacy of Cubism is still at work but the artist now makes use of any artistic or stylistic means he wishes, depending on whether he wants to give the head a solid structure, to apply the paint with the greatest subtlety, or to contrast painterly finesse with crudely vehement brush-strokes.

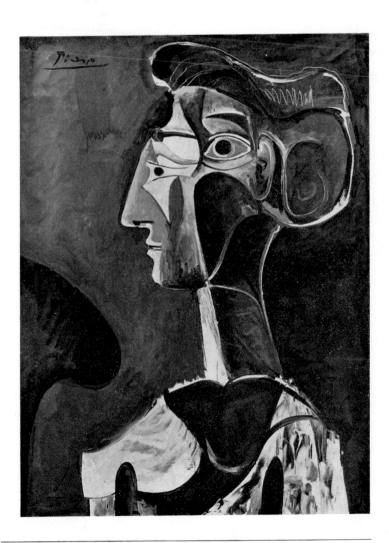

110
Feuerblume 1972
Fire Flower

Pigment and fire on canvas, 130×196 ($51\frac{1}{8} \times 77\frac{1}{4}$)
Signed on reverse and on frame : Piene 72

His preoccupation with light led Otto Piene to adopt fire as one of his habitual media. His smoke pictures were done in 1959 and his fire paintings and gouaches date from 1961. In 1962 Piene wrote 'I wanted to breath life into it (the light), to release it from its passivity. One way of achieving this, which I have used since 1959, has been to work with smoke directed through the plates which I used for my white and yellow stencilled pictures. The smoke drawings whose serial structures suggest a vibrating movement were done like this. After that I used smoke on canvas. Here the vibrating effect becomes a pulsating one comparable to breathing or heartbeat. Red turned out to be the most appropriate colour for smoke and I experienced it in many new ways. At the same time, by allowing the smoke to stain the colourless canvas, I was also referring back to colourless colour, to the whiteness of light'.

111
Number 32 1950

Duco on canvas, 269×457.5 ($106 \times 180\frac{1}{8}$)
Signed and inscribed on reverse : No 32 1950 Jackson Pollock

Jackson Pollock was the central figure of American Action Painting or Abstract Expressionism. He died as a result of a motor accident in 1956. In this huge painting, over four and a half metres across, the fluid black paint is spattered, dripped and poured straight from the can. The picture is no longer considered traditionally as something finite but more as an excerpt from some limitless movement. The untrammelled action, the conscious, even enthusiastic acceptance of chance effects do not interfere with the dominant, almost dance-like rhythm of the painting.

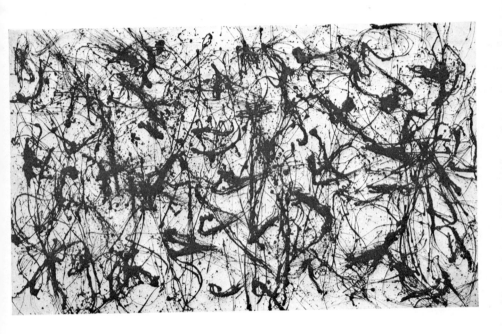

112
Wager 1957-9

Oil and assemblage of objects on a four part canvas, 206 × 376 (81$\frac{1}{8}$ × 148)
Unsigned

This powerful picture still contains a great deal of the expressive vehemence of
Action Painting, though its neo-Dadaist features point beyond the scope of that
movement. The central area is an arena for uninhibited painterly action. To it are
glued various banal everyday objects like socks and ties which have no intrinsic
value but are simply incorporated in the riot of paint. In the right-hand section
the artist has included a life-size nude self-portrait, drawn by outlining the con-
tours of his own body – a purgative, 'anti-artistic' way of relating art to reality.

Robert Rauschenberg b.1925

113
Quote 1964

Oil and silk screen on canvas, 239 × 183 (94¼ × 72)
Unsigned

In this somewhat later picture Rauschenberg explodes the conventions of pictorial composition in three ways. Firstly, technically, in that he uses the silkscreen process to print press photos and reproductions of paintings onto the canvas. Secondly, in terms of subject matter, in that he introduces real things into the picture with almost no allegorical motive. And finally, in the compositional sense, in that he groups these elements in an apparently arbitrary fashion. These innovations signify the end of Action Painting in American art. In 'Quote' the areas of black paint still relate to Abstract Expressionism, and the brush strokes are still used specifically to heighten or adjust the effect. But the difference is that unvarnished reality is now brought into the picture, through photographs of President Kennedy, a parachutist (printed twice), and a collection of road signs. Throughout the painting reality and powerful pictorial forces are engaged in constant dialogue.

114
Number 118 1961

Oil on canvas, 290 × 260 (114$\frac{1}{8}$ × 102$\frac{3}{8}$)
Signed on reverse : MARK ROTHKO 1961

Although the painting is constructed from large rectangular areas of colour, Rothko does not use these forms for geometric reasons. He leaves the edges of the colour fields somewhat blurred, and the colours create a slight but definitely discernible vibration. They are not so much colour areas as substances and spaces of colour. For colour is experienced as a force defining space and substance. It is also manifest as a spiritual force. The silent, floating areas of colour seem imbued with deep spiritual meaning.

Reproduced in colour on p. 22

114

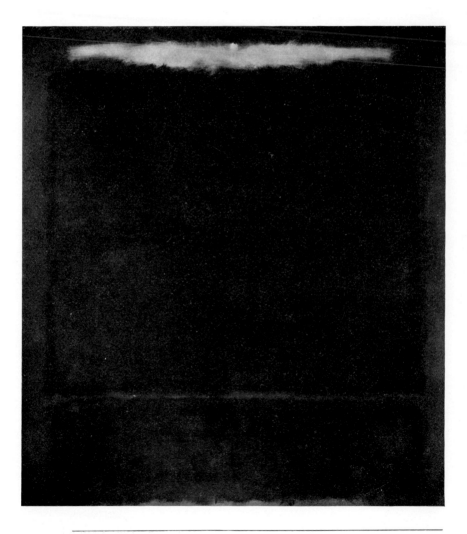

115
Marocain *c.*1913
Moroccan

Oil on canvas, 102×69 ($40\frac{1}{8} \times 27\frac{1}{8}$)
Signed bottom right : G. Rouault

Although Expressionism was a primarily German tendency, its basic attitudes are also demonstrated in this melancholy head of a Moroccan by the French painter Rouault. The expressive quality of the picture is due to neither of the major liberating artistic discoveries of the twentieth century, namely the Fauvist principle of pure colour and the Cubist principle of pure form. It depends rather on the dark glow of the colours and the way the features are transformed into a tragic mask, giving the face an intense, visionary quality.

Oskar Schlemmer 1888-1943

116
Frauen am Tisch 1923
Women at Table

Oil on canvas, 73×61 (28¾×24)
Signed and inscribed on reverse : Frauen am Tisch 1923 O Schlemmer

Oskar Schlemmer taught at the Bauhaus from 1921 to 1928. The fundamental theme of his art was a belief in the power of form and its manifestation in the subject of the figure in space. In his work the human figure is deprived of any individuality and reduced to a multiple rhythmic element in the picture. But his rather severe compositional approach does not exclude the poetic moment of emotion, especially in this early, dark-toned painting where the colour and in-tellectual atmosphere are reminiscent of the work of Schlemmer's teacher and mentor, Otto Meyer-Amden.

117
Gruppe am Geländer 1 1931
Group at the Banisters 1

Oil on canvas, 92.5 × 60.5 (36$\frac{3}{8}$ × 23$\frac{3}{4}$)
Signed and inscribed on reverse : 27. – 28. Aug 31 'Gruppe am Geländer 1' O.S.B.
Osk Schlemmer Breslau

The four figures in Schlemmer's 'Gruppe am Geländer 1', who are in fact Bauhaus students, are in some respects more life-like than those in the previous picture, yet at the same time they are also more abstract. The atmospheric quality of the 1923 painting has given way to the clear, rational air – or airlessness – of the Bauhaus. Schlemmer even chose a real Bauhaus setting, namely the staircase of the building designed by Gropius for the school in Dessau. The stereotyped figures fulfil a solely compositional function. By the time he painted this work, and also the great 'Bauhaustreppe' in New York, Schlemmer had in fact left the Bauhaus and was teaching at the Academy in Breslau. Nevertheless, the influence of the Bauhaus is not only thematic; the picture symbolizes its whole artistic and intellectual approach.

118

Grosses rotes Bild 1965
Large Red Painting

Mixed techniques on canvas, 150×270 ($59 \times 106\frac{1}{4}$)
Signed bottom right : Schumacher 65

Like many other artists of his generation, Emil Schumacher employs the language of graphic action. He combines it with a kind of painting which ceaselessly re-defines itself as such. Schumacher sweeps aside civilised ideals of beauty asso-ciated with style and discovers a beauty of a totally different kind through the expression of paint as material. Emphasis on structure is combined with expressive gestural handling and landscape reference.

Emil Schumacher b.1912

119
Macumba 1973-4

Acrylic on paper and sacking, 137 × 184.5 (54 × 72⅝)
Signed bottom right : Schumacher 73/74
Inscribed on reverse : B-5/1973 'MACUMBA'

In 'Macumba', done almost a decade after the 1965 picture, areas of painted,
torn paper are collaged onto sacking while streams of fluid colour over-run both,
down the surface of the picture. A freely drawn black arch crosses the top of the
painting. Arches such as this, often very broad and spanning large and powerful
pictures, have become the dominant theme in Schumacher's work of the last few
years. He constructs the form again and again, but each time with a renewed
spontaneity specifically of the moment of creation : a repeated painterly gesture
but one which nevertheless does not appear constant, and which he achieves on
each occasion with new intensity.

120
Merzbild 9 b.Das grosse Ichbild 1919
Merz Picture 9 b. The Large Self Portrait

Collage and mixed techniques on cardboard, 97×69.5 ($38\frac{1}{4} \times 27\frac{3}{8}$)
Signed bottom right: KS 19
Signed and inscribed on reverse: Merzbild 9 b Kurt Schwitters 1919 Das grosse Ichbild.
On permanent loan

During the First World War Schwitters passed through a brief Expressionist period, and much of the intensity and cosmic yearning of Expressionism is still apparent in the large 'Merz' Pictures of 1919 and 20. In them the restrained pathos of Schwitters' romantic inclinations is merged with a wide range of Cubist and Futurist forms, and above all with the irreverent Dadaist use of materials He nailed, screwed and glued his compositions together out of all kinds of decaying rubbish. He gave the first of these compositions the meaningless title 'Merz', deriving from the remnant of a sticky label bearing the words 'Kommerz- und Privatbank' which happened to be in the picture, and subsequently adopted the word as a general title for his pictures which he called 'Merzbilder'. 'Merz', in fact, was Schwitters' own private version of Dada.

121

Merzbild 25 A. Das Sternenbild 1920
Merz Picture 25 A. Star Picture

Montage, collage, and oil on cardboard, 104.5 × 79 (41 × 31⅛) (in its original frame 112 × 87 cm)
Signed bottom left : KS 20
Signed and inscribed on reverse : K. Schwitters 1920 Merzbild 25 A Das Sternenbild

In this picture the celestial bodies of Expressionist yearning are transformed into sad discs of tin and cardboard, the shabby, worthless refuse of everyday life with decomposed surfaces and gnawed edges. They are much less stars in the skies than symbols of the misery and distress of the first post-war years. Scattered among these remnants of the everyday world are scraps of daily newspapers, which introduce topicality into an abstract composition in a far more passionate and alarming fashion than in the earlier collages by Picasso and Juan Gris.

122
Mz 150. Oskar 1920

Collage on cardboard, 13.1 × 9.7 (5⅛ × 3⅞)
Signed and inscribed bottom left and right on the cardboard backing : Mz 150
Oskar K.S.20.
On permanent loan

This small collage has something of the dark spaciousness of the large 'Merz'
compositions. It has the effect of a 'Merzbild' in miniature with a large 'star' in a
dark blue night 'sky' hovering the scraps of paper which suggest the 'earth'.

123
Mz 169. Formen im Raum 1920
Mz 169. Forms in Space

Collage on cardboard, 18×14.3 ($7\frac{1}{8} \times 5\frac{5}{8}$)
Signed and inscribed bottom left and right on mount:
Mz 169 K. Schwitters. 1920. Formen im Raum.

Somewhat confusingly, Schwitters referred to his collages as 'Merz drawings' in order to distinguish them from the large scale compositions. He worked on these drawings in an unbroken sequence from the winter of 1918 until his death in 1948. In them he was able to abandon himself freely to the graphic play of forms. However, although he was fascinated and inspired by chance effects of form and colour among his fragments of paper, he was always primarily concerned to create order. Schwitters stood apart from the anti-art slogans of the other Dadaists and never tired of emphasizing that art is essentially a question of balance, and of stating unequivocally that 'Merz is form'.

124
Mz 271. Kammer 1921

Collage on cardboard, 17.8×14.3 (7×5⅝)
Signed and inscribed bottom left and right on mount:
Mz 271. Kammer. K. Schwitters. 1921.

125
Young Earnest 1946

Collage on canvas (a book cover) over cardboard, 19.5×16.2 ($7\frac{5}{8} \times 6\frac{3}{8}$)
Unsigned

In 1940 Schwitters fled from Norway to England. After seventeen months in various internment camps he settled in London. In 1945 he moved to Little Langdale near Ambleside in the Lake District where he died in 1948. After a Constructivist period in the twenties and early thirties he finally returned to his concept of 'Merz' art, to an art based on materials, on refuse and collaged scraps of paper.

126
Flying Thought, 12.II.1958, 16.53-23.09

Tempera on photographic paper on canvas 108.7 × 69.7 (42¾ × 27½)
Signed bottom right : Sonderborg 58

Sonderborg, a Danish-born artist living in Germany, executed his first paintings concerned with speed in the early fifties. They act as a kind of stop watch for the speed of the painting process. Associations of jazz, flight, rockets and explosions give the flat trajectory of this pictorial movement a flavour of 'reality'. One can imagine the composition as a flight path with massed clouds whirling and spiralling along the edges.

126

127
Window, 27. April 1965, 11.31-12.43

Tempera on photographic paper on hardboard, 108×70.3 ($42\frac{1}{2} \times 27\frac{3}{4}$)
Signed bottom right : Sonderborg 65

Sonderborg later moved away from the illusionistic rendering of speed evident in the earlier picture. In works such as this example from his 'Window' series he began to compose pictures where the speed of the painting process is absorbed into more static, yet vibrating structures.

128
8 Décembre 59 1959

Oil on canvas 201.5×162 (79⅜×63¾)
Signed bottom right: Soulages
Signed and inscribed on reverse: 8 DEC 59 SOULAGES

The basis of Soulages' work is the act of painting. However, he is not solely concerned with the expressive-quality of gesture but also with pictorial clarity, order and beauty. At no point does vehement painterly action detract from pictorial brilliance nor do dynamic, structural or expressive effects cheat the eye of its expectation of beauty. Soulages does not shun painterly sophistication, he combines it with painterly vitality to create the glowing blackness which characterizes his pictures.

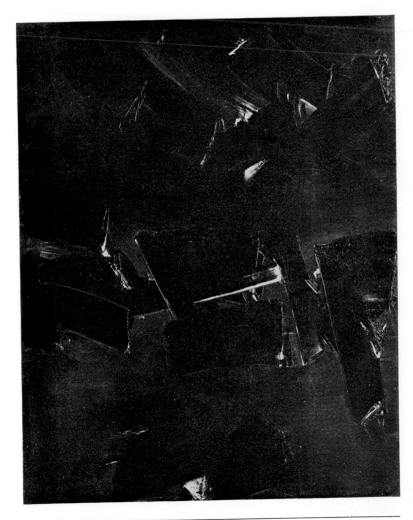

129

Figure au Bord de la Mer 1952
Figure by the Sea

Oil on canvas, 161.5×129.5 (63⅝×51)
Signed bottom right: Staël

Immediately after the war Nicolas de Staël was one of a small group of artists in Paris specialising in a dark-toned kind of Abstract Expressionism modified by the example of Georges Braque and his principle of the 'règle qui corrige l'émotion'. In de Staël's later paintings – he committed suicide in 1955 – the expressive quality receded in favour of clarity and luminosity of colour and form, and finally also in favour of figurative representation. 'Figure by the Sea', though a relatively late work, is a striking example of his dynamic approach. However this dynamism is no longer expressed in violent pictorial movement, but concentrated within the blocks of colour.

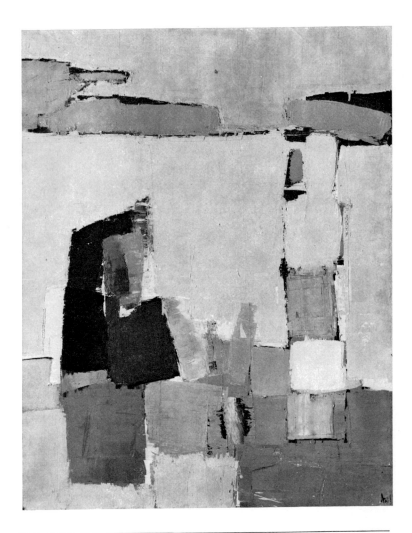

130
Delphine and Hippolyte 1959

Enamel paint on canvas, 230 × 336 (90⅛ × 131⅜)
Signed on reverse : F P Stella 1959

This is one of a series of black stripe-pattern pictures which Stella did in 1959 and 1960. The structure of the painting is one of radical simplicity. A brightly outlined diamond shape stands at the centre of each of the two axially-converging halves of the picture, and is surrounded by other diamond shapes, equally spaced and increasing in size. The geometric configuration thus fills the entire picture surface and has the effect of suggesting that the picture is itself part of some more extensive structure. For all its rational logic, there is still a definite element of the emotional and irrational in this early work, in the 'African' blackness and the gentle vibration of the unpainted 'negative' areas of the white lines.

131
Le Festival de l'Auto-Route 1965
Motorway Festival

Oil on canvas, 250×200 (98½×73¾)
Signed bottom right : SUGAI 65
Signed on reverse : SUGAI 1965

Kumi Sugai is a Japanese artist living and working in Paris. For many years he used a formal language of symbols close to handwriting. Then in the 1960s he adopted the heraldic forms of the American Hard Edge movement. In this picture ornamental and sign-like qualities join forces on the one hand with the symbolism of his native country and on the other with his overwhelming impression of motorways with their signposts and their 'coldness' which was subsequently to figure increasingly in both the themes and titles of his paintings.

132
Dame à l'Absence 1942
The Absent Lady

Oil on canvas 115 × 89.5 (45¼ × 35¼)
Signed bottom right: YVES TANGUY 42

The method of representation is naturalistic, almost photographic. It faithfully
reproduces the substances and spatial quality of things as if they were real, but
real in the context of another planet, another sphere—in short 'surreal'—though
they stand beneath a very naturalistic, overcast yellow sky. It is as if these ob-
jects — a mighty female figure, some smaller figures, and all kinds of colourful,
toy-like petrifactions — are the relics of a distant age, fossils from a long extin-
guished existence which have somehow survived in an eternity devoid of all
human life.

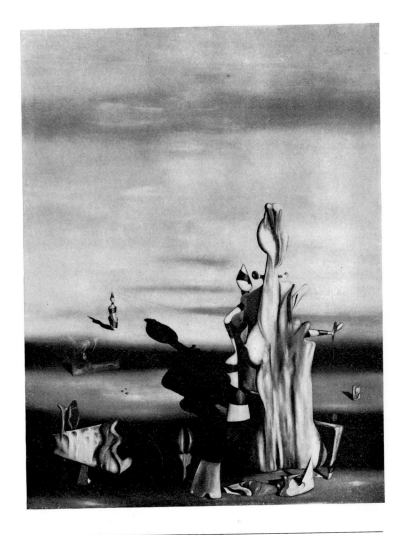

Antoni Tàpies b.1923

133
Grande Peinture Grise 1955
Large Grey Painting

Mixed techniques with sand on canvas, 195 × 169.5 (76¾ × 66¾)
Signed bottom right : tapies – 55
Signed and inscribed on reverse : TAPIES – 'PINTURA'

In about 1950, like many artists of his generation, Antoni Tàpies became involved
in the widespread preoccupation with materials. He had been influenced early
on by Surrealism, but it was only in the fifties that he moved into the world of
'art informel' to which he has since contributed a great deal. He regards material
as an accomplished fact whose existence can only continue further in a process
of decaying, crumbling and dying; the personality of the artist contributes
nothing but the occasional mark or line. This dark grey picture of 1955 contains
incisions, in the shape of a wing-like form and a white cross, that look like
cuneiform characters. One is reminded of a wall, a stele, some discovery from
ancient times covered with mysterious ciphers, which defy interpretation and
yet seem somehow significant. The puzzle is not solved but painted.

134
Relief en Couleur Brique 1963
Relief in Brick Colour

Mixed techniques with sand on canvas, 260×195 (102$\frac{3}{8}$×76$\frac{3}{4}$)
Signed on reverse : tàpies – 1963

This later work by Tàpies is simply a piece of rusty red wall ; a large, mysterious mass of masonry. Space is denied with solemn reticence, material abandoned to its own melancholy.

135
Plane of Poverty 1960

Oil on canvas, 186×112 (73¼×44⅛)
Signed bottom right: Tobey 60

Mark Tobey was born in 1890, but his place is within the post-1945 art scene. He visited China and Japan as early as 1934 and the experience of oriental calligraphy has had a lasting effect on his painting. Up to the early 1940s he continued to combine this calligraphic approach with the city themes of his early years, but subsequently abandoned any reference to objective reality. Over and over again the fine-spun web of colour gives tension and structure to Tobey's work and its rransparency suggests a feeling of endless space. Within the uniform, almost monochrome network of this comparatively large-scale painting the observer gradually discovers more and more formal movement and hidden chromatic riches.

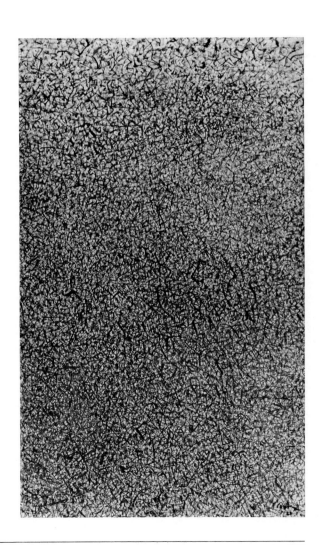

136

Shadow Spirits of the Forest 1961

Tempera on paper, 48.4 × 63.2 (19 × 24⅞)
Signed bottom right : Tobey 61

In 1960 Tobey left the United States and settled in Basle where he still lives. Both this luminous gouache and 'Plane of Poverty' were executed shortly after his move to Switzerland. This second painting also consists of a filigree-like web of innumerable lines ; its silent movement has the quality of a meditative manuscript.

137

Feld 1974
Field

Nails on canvas on wood, polyester varnish with pigment,
160×160×17 (65×65×6¾)
Signed and inscribed on reverse: Feld 1974 Uecker

Nails are Günther Uecker's obsession. He began towards the end of the fifties
with line upon line of nails on trays and warped planks. Subsequently he made
these severely mathematical rows looser and allowed the nails to creep over
furniture and objects, and a rhythmic swinging, gyrating, whirling movement
enters the dense fields of their arrangement in his predominantly square or
circular pictures. Real movement is also often introduced into the nail reliefs.
However, most important of all is the essential, dematerialisation of the nails by
light. For light is Uecker's other and ultimate obsession. The nail structures both
render light visible and experiential. The immaterial, asensual qualities of light,
its purity and its spirituality are represented in Uecker's artistic philosophy by
the absoluteness of white.

138
Les Drapeaux 1939
The Flags

Oil on canvas 80×140 ($31\frac{1}{2} \times 55\frac{1}{8}$)
Signed bottom right : Vieira da Silva Août 1939

Like so many post-war artists, the Portuguese painter Maria Helena Vieira da Silva began her career as a Surrealist. These origins can be seen clearly in works such as 'Les Drapeaux'. This painting consists of a mosaic-like pattern of small diamond shapes into which a non-perspectival kind of space is woven in a most disconcerting way. Through it wanders a procession of flags in the midst of which a crucified figure stands out with shifting clarity against the decorative surface. Reality is seen simultaneously as a phantom and – in the first year of the war – a real threat.

138

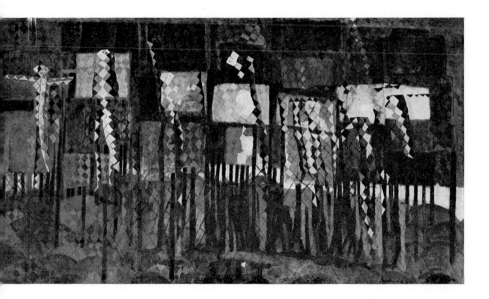

Maria Helena Vieira da Silva b.1908

139
Le Métro Aérien 1955
The Overhead Railway

Oil on canvas, 160×220 (63×86⅝)
Signed bottom right : Vieira da Silva 55

This 1955 cityscape composed of lines and dashes is almost monumental in feeling, and unquestionably abstract. Not a single detail can be identified as a particular object, yet we are tempted to recognise in it various things from the world of our experience, or even to see the picture as a whole in terms of an actual scene. The eye involuntarily interprets the large arch-shape as a bridge or similar wide-spanned iron construction. The drama of the picture is a drama in space. It is like some corner of nature taken over by the human will, or a gigantic building site where great masses of earth are being moved, stakes driven in, rails shifted. Yet earth, air, space and man-made construction are simply materials for the freedom of movement and imagination on the picture surface.

Andy Warhol b.1928

140
Woman Suicide 1963

Silk screen on canvas, 313×211 (123⅝×83⅞)
Unsigned

Using the silkscreen process, Warhol has printed several rows of the same police identity photograph thus evoking the horrific yet commonplace reality of suicide, the reality of police files, of the mass media – especially films. There is a continual fluctuation of the colour intensity and an intentional yet random shifting and overlapping of the individual images. Though no attention is paid to aesthetic effect, the artist nevertheless creates an aesthetic interpretation of reality.

140